K. Baker

The
Canon Manual
Paul Jonas

AMPHOTO

American Photographic Book Publishing Company, Inc.

Garden City, New York

Library of Congress Catalog Card No. 72-77137
ISBN 0-8174-0486-4

Illustrations of the various Canon cameras and accessories are
presented through the courtesy of Canon U.S.A. Inc.,
New York City. All other photographs are by the author.

Preface

Several events and factors have helped to make the Canon Camera Company Japan's largest manufacturer and exporter of cameras. In its almost 40 years of constructing high quality cameras, Canon was the first to introduce rare earth glass into its lenses and the first Japanese manufacturer to end the unabashed imitation of European cameras.

A simple financial statement underlines this unprecedented development: In the last 25 years the company's paid-in capital has increased a thousand-fold.

In 1933, Dr. Takeshi Mitarai, a physician who later gave up his practice to devote his full energies to the development of fine cameras, lenses, and accessories, and who is still president of the Canon Camera Company, founded a small institute for the purpose of designing and constructing a high quality 35mm camera. Three years of intensive research and experimentation led to the production of the first Canon camera. In 1939, the company began manufacturing Serenar lenses, which soon gained a world-wide reputation. Each new Serenar lens—all are now called Canon lenses —added to the firm's already impressive reputation. At the same time, innovations and improvements in the camera body kept pace with the development of lenses, and Canon cameras were to be found in use all over the world.

The success of the Canon camera is a direct result of its precision engineering and construction. The company itself has such confidence in the durability and workmanship of its products that since 1950 it has issued a five-year guarantee on all Canon cameras and lenses. Having a fine camera and lens backed up by such a long-term guarantee is heartening news to all present and prospective Canon owners. They assure them of many years of happy and successful picture taking.

PAUL JONAS

Contents

The Bases of Photography and the 35mm System

Camera Construction

Long before Daguerre invented photography, the *camera obscura* was well known among educated people. Since we know much more now than people of past centuries, we tend to forget that the image produced by that mechanical marvel, the modern camera, is produced by the same simple phenomenon on which the *camera obscura* was based.

Although the basic phenomenon remained a simple one, the tools used to record it have improved immensely. Now this phenomenon may be captured under almost any circumstances. By the continuous development of photography we have reached a level where we may capture a situation or a scene as easily on film as we may by sight, and, what is more, we may even record on film images we are unable to see.

However, the base has remained the same. All the ingredients of the *camera obscura* are present in modern cameras such as the various models of the single-lens reflex and rangefinder Canons. Thus, the screen of the *camera obscura* was replaced by film placed into the focal plane of the Canon (literally, the screen is kept in the single-lens reflex in the form of the ground glass of the prism-viewing system), and the hole in the middle of the front board was replaced by a lens. Some other refinements made the modern *camera obscura* easier to handle: the shutter; focusing system; diaphragm; film transport, with all its complex functions; exposure meter; etc. Now let us examine these refinements. My goal, however, is not only to introduce these innovations to you, but by explanation of their functions, to let you use them more intelligently and efficiently.

Loading the film

A light-sensitive material is loaded into a light-tight holder and placed into the focal plane to become exposed by light. This light-tight holder in 35mm photography is a cartridge loaded with about 5½ feet of perforated movie film. The end of the film is pulled out of the cartridge about four inches in order to make it possible to fasten the film to the take-up spool (and to place the film in the correct position in the focal plane and on the cogs of the transport system) in full light. Once the film is positioned correctly in the focal plane, and is fastened to the take-up spool according to instructions or automatically by the QL (quick loading system), there need be no concern about correct performance during transport . . . were it not for one or more of the several errors that might impede the picture-taking process. Possibilities for error start in the loading of the cartridge (if we use bulk film). The end of the film is likely to get loose from the spool if it is not fastened properly and firmly. Therefore, check by pulling the film strongly before you start winding it.

Wind the film tightly, but avoid pulling the remaining film during winding; scratches will result from such rough treatment. Before you load a cartridge, be sure that the velvet does not fray. If it does, white lines may show on the edge of the picture due to the shading effect of the shred.

Greatest care must be taken to load the cartridge as well as the camera in a dust-free space. If dust gets on the pressure plate of the camera, scratches on the film are inevitable. The job of the pressure plate is to hold the film exactly in focus during exposure. Since the curl of the film is quite strong, firm pressure is needed to hold the film completely flat in the film gate. When the film slips in front of the pressure plate, friction is set up between them. Because the pressure plates of Canon cameras are ground and polished, this friction cannot cause any marks if there is no foreign material such as dust or split-film between them. So, not only must the cartridge be kept clean, but every time you load the camera, you should blow out and brush out all foreign matter on or behind the pressure plate, in the cartridge receptacle, on or behind the take-up spool, and anywhere else inside the camera body.

The shutter and the film gate

Before you load your camera, take a look at the film gate. The size of this gate is exactly 24 x 36mm in conventional 35mm cam-

eras, and in the Canon you find it covered by a curtain. This curtain (actually two curtains) is the most vital part of the focal plane shutter. Its function is to regulate the time of exposure within wide ranges, by having a slit travel along the film gate. Since the running speed of the slit is constant, the exposure time can be determined by the width of the slit. The narrower the slit, the shorter the exposure time.

As the actual speed of the slit is not too great, the entire surface of the film is exposed over a relatively long period, but gradually, as the slit advances. This slow speed is the cause of a well known phenomenon, apparent when the wheels of a fast-moving vehicle show elliptical distortion. This distortion has a horizontal trend if the vehicle is running in the direction opposite to that of the focal plane shutter. (The image of the vehicle in the focal plane is reversed and runs in the direction of the running slit, so the exposure on the film takes a spun-out shape.) The distortion takes on a vertical trend if the vehicle is running opposite to the direction of the slit and a diagonal one if the camera is held in the vertical picture-taking position (the shutter is running upward or downward).

Exposure times below 1/60 sec. are determined by the interval at which the second curtain, which closes the gate, follows the first curtain, which opens it. At an exposure time of 1/60 sec., then, the first curtain has just finished its run when the second curtain starts, leaving the entire gate open for that time. Therefore, the shortest possible exposure time for synchronizing speedlight is the fastest shutter speed at which the film gate is completely open, since the duration of the speedlight is much shorter than the running speed of the curtains. On the shutter speed dial of many modern cameras you will find an X-mark. If the dial is set to this mark, the shutter is set for the use of speedlight. The focal plane is wide open for an instant at X synchronization. Of course, you can also use shutter speeds slower than the X setting, since the film gate is necessarily completely open for a while at these slower settings. The use of flash bulbs is quite different, but I will explain this in Chapter 5.

Another type of shutter is used in the Canonet, which is the latest model among fully automatic electric-eye cameras. This shutter, called the leaf-type shutter, is placed between the lens elements in front of the diaphragm. It works in such a way that the blades of the shutter, which close the whole diameter of the lens when the shutter is not working, open for the preselected exposure time at the instant when the shutter-release button is actuated. This type of shutter is used mostly in non-interchangeable lens cameras, and

usually 1/500 sec. is the highest shutter speed that can be achieved. It has one advantage, however. The speedlight can be synchronized at all shutter speeds, because it exposes the entire surface of the film simultaneously.

Advancing the film

Now we know the most important instrument of the film gate, which exposes the film for a previously determined length of time. When the exposure is made, the film has to be advanced in order to put an unexposed area of film into the film gate to be used to record the next picture. This is done by operating an advance mechanism, which is either a knob, lever, or trigger, depending on the make and type of camera. The latest Canon cameras feature a lever on the top of the camera. The advance mechanism is a very complex unit. Besides advancing the film exactly one frame length, it cocks the shutter and releases the double-exposure prevention mechanism. In single-lens reflex (SLR) cameras less advanced than the Canon, the film-transport system is connected with the mirror, which is returned to the viewing position by the transport system, and perhaps with the diaphragm, which is reopened to full aperture by it. Since the Canon has an instant-return mirror and instant-reopen diaphragm, the advance lever is not responsible for these operations. They are completely automatic.

Lens Lore

Now that we know what happens in and around the focal plane before, during, and after exposure, let us see how the light is projected onto the film, and what the important factors controlling the quantity and quality of light during its projection are. The lens is the most important of the devices that determine how the image is formed on the film.

It is not the task of this book to give a complete explanation of what a lens is made of. The reader would not take better photographs if he knew that a Canon lens is the result of several years of research and the complex studies of several hundred mathematicians and, in recent times, some computing machines. The fact is that rare-element glasses are used according to the highest possible standards of manufacturing, grinding and polishing. The 5, 6, 7, or perhaps 11 elements of a Canon lens are assembled by such rigidly maintained standards of precision that a 1/25,000 inch difference is intolerable.

10

It is much more important for the reader to know what the features of the lenses are and how to make the best use of the magnificent Canon lens in front of his camera. Besides the inherent features of resolving power (the measurement of how sharp an image a lens will produce), image contrast and the relative lack of reflection and glare, focal length, and relative aperture also determine the quality and performance of a lens.

Focal length

The focal length of a lens is expressed by the distance of its optical center from the focal plane when the lens is focused at infinity. Usually, the optical center is placed between the lens elements in about the same plane as the diaphragm. But some lens constructions feature a displaced optical center. This displaced optical center can be in front of the entire lens construction (in the case of real telephoto lenses), or behind it (in the case of the retrofocus type of wide-angle lenses). This displaced optical center does not necessarily have to take place outside of the lens construction, but only closer to or farther from the focal plane than its place would be in a conventional construction.

The displaced optical center makes for a shorter overall length for telephoto lenses and a greater distance between the rear element and the focal plane in wide-angle lenses. The latter is important in the case of SLR cameras to allow sufficient space for the swinging mirror.

The focal length of the lens determines its angle of view and magnification. The greater the focal length of the lens (in comparison with the focal length of the normal lens for the negative format), the narrower its angle of view and the greater its magnification or telescopic effect. Conversely, the shorter the focal length, the wider the angle of view. In the final chapter you will find tables that indicate the angle of view and the power of magnification (related to the normal lens) of Canon lenses of different focal lengths.

For the standard, normal lenses of the Canon, and for other 35mm cameras, the 50mm focal length (slightly longer or shorter) was chosen as normal. So, lenses under 50mm focal length (such as 19mm, 25mm, 28mm and 35mm) are called wide-angle lenses; on the other hand, the 85mm, 100mm, 135mm, 200mm, 400mm, 600mm, 800mm, and 1000mm lenses are called (depending upon their construction) long-focus or telephoto lenses. As a matter of fact, all the long-focus lenses are usually called telephoto lenses

11

(sometimes incorrectly), so you should not be confused when you hear this term. The lens is not necessarily a real telephoto lens with a displaced optical center.

Of course, all Canon cameras feature lens interchangeability. You can realize the importance of this feature when you hear that old photographic proverb which says that you have as many different cameras as you have different focal-length lenses, even if you actually have only one camera body. How to make good use of lens interchangeability and how to achieve special effects, you will learn in Chapter 5.

Aperture and diaphragm

Another characteristic of a lens is its maximum effective aperture. This determines how fast a lens is when the widest aperture is used. The maximum effective aperture is calculated by dividing the focal length of the lens by its exit diameter (this is the diameter of the lens that we see when looking through the lens; it is sometimes not equal to the diameter of the front element). The maximum effective aperture is engraved on the setting of the front element in the form of a ratio such as 1:1.4, or 1:2.8, etc. The lower the number, the greater is the aperture and the amount of light that can go through it. But, generally, we do not need the maximum amount of light that can be transmitted through the lens. Therefore, we have to regulate the amount of light. This job is performed by the diaphragm, which is placed among the elements of the lens in the form of a variable-size hole formed by overlapping steel blades. The setting of the diaphragm is accomplished by turning a ring mounted on the lens barrel. The ring contains numbers which indicate the f/stops. These f/stops are calculated in the same way that we determine the greatest aperture of the lens. For example: $f/4$ indicates, in the case of a 50mm lens, that the visible aperture has a diameter of about 12.5mm (50 divided by 12.5 is 4). Because the basic aperture is an essential factor of lens performance, the sequence of f/stops starts with the largest aperture and, usually, each succeeding f/stop permits half the amount of light to go through the lens as the one preceding it in the sequence. I used the word "usually," because sometimes the largest aperture differs from the internationally accepted sequence (as 1:1.8 or 1:3.5 do), so the transmitted amount of light is not halved at the next f/stop, but all the numbers following the second are in perfect mathematical sequence. The international f/stop sequence is 1, 1.4, 2, 2.8, 4, 5.6, 8, 11, 16, 22, 32, and so on (it is a logarithmic progression).

You will find part of this series on your lens barrel. I repeat: Each successively greater f/stop number allows half the amount of light to go through the lens as the one preceding it.

Relationship between aperture and shutter speed

For the film to receive a correct exposure there must be some relation between the f/stop and the shutter speed. Thus, if I change the f/stop, I also have to change the shutter speed in order to allow the same amount of light to come through the lens. For instance: if I used 1/500 sec. at f/8, and if for some reason I have to use f/16, I have to change the shutter speed to 1/125 sec., which is only ¼ as fast as 1/500. In this way, the film receives the same amount of exposure in both cases. As you can notice on the shutter speed dial of Canon cameras, each successive shutter speed is exactly double or half the previous one (depending on which way we go). It is very easy, then, to calculate the correct mathematical exposure, since the f/stops follow the same relationship. To lay stress upon the definition of correct exposure I deliberately omitted the function of the built-in exposure meter that, by the means of cross coupling, automatically sets one of the exposure factors, while the other is changed.

But once we have determined a correct exposure, with the help of an exposure meter, and we set the diaphragm and shutter speed according to the reading, why should we change one or the other component of this complex called exposure? By getting acquainted with the answers to this question, we step up to a higher level in our photographic knowledge. Before making this step, we have to know some other elementary manipulations with the camera, and first among them, focusing.

Focusing

When I explained previously that the focal length of a lens is measured when the lens is focused at infinity, it may have occurred to you that the distance between the optical center of the lens and the focal plane has to be changed when the lens is focused for a closer distance. The closer the object is to the camera, the greater is the distance needed between the lens and focal plane to get a sharp image of the object.

Modern cameras focus either through the taking lens, as in single-lens reflexes, through a matched-focusing lens, as in twin-lens reflexes, or through a separate rangefinder-viewfinder coupled

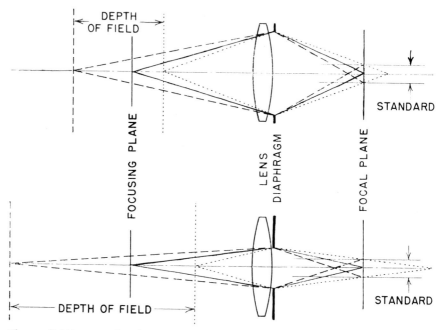

The solid line marks the cone of the light rays coming from an object lying in the focused plane. The broken line belongs to the object lying behind the focused plane, and the dotted line marks the light rays coming from objects lying between the focused plane and the camera.

to the lens. In the rangefinder system the object is seen from two positions. Thus, two images of the object are produced. These images are projected into one eyepiece through mirroring prisms. One of these prisms can be turned, so that two images can be made to coincide. The turning prism is connected mechanically with the lens barrel, and the entire mechanism is installed in such a way that the two images in the eyepiece coincide when the lens is focused on the object. In this indirect way we can focus very easily and exactly; we only have to turn the lens barrel or focusing lever until the two images of the object of focus are brought together.

The single-lens reflex system works in a direct way. We actually see on a ground glass what is sharp and what is out of focus, since we see the image actually projected by the lens. This image is diverted by a swinging mirror into the eyepiece of the combined viewing-focusing system. This ground-glass image is inverted by the pentaprism into an upright position and is magnified by the magnifying glass built into the eyepiece. By this means we see a life-

size image when a normal lens is placed into the camera. When a long focus lens is used we see an enlarged image, and a smaller-than-life image when a wide-angle lens is placed into the lens mount. At the instant of exposure the mirror swings out of the way, allowing the image to fall onto the film when the focal-plane shutter opens the film gate.

After exposure, the mirror swings back into its original position in the more advanced cameras such as the Canon F series. This entire operation happens in such a short time that, because of the inertia of the human eye, we do not realize that the image in the viewer was momentarily cut off, and we see the image continuously.

Depth of Field

Focusing is accomplished by turning the lens barrel. We actually see the movement of the sharp zone produced by the lens. This sharp zone is called *depth of field.*

From the depth-of-field scale engraved on the lens barrel we can determine the necessary f/stop and focusing distance for the area we want to be sharp—in this case from the photographer to the boys on the pony.

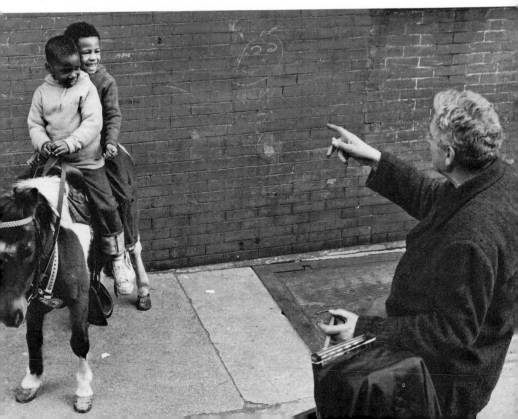

Literally, depth of field means the area in which objects are projected with acceptable sharpness by the lens onto the focal plane. Acceptable means equal to a certain standard based upon the average resolving ability of the human eye, in connection with the degree of enlargement of the negative and with the convenient viewing distance of the print.

I don't want to load you with mathematical calculations and logical derivations to explain how and why the standard of sharpness was determined; you have to know only that such a standard exists, and everything which is above the accepted standard falls within the realm of sharpness. However, if you are interested in such technical matters you may find it in one of my previously published books, *Improved 35mm Techniques*. In any case, I have to explain the entire idea of depth of field to help you understand why a shorter focal length lens gives a greater depth of field than a longer one, why depth of field is decreased when we focus at shorter distances, and why depth of field is increased when we close down the lens diaphragm. From these statements it may be seen that depth of field is a flexible and complex thing, and that it is connected with the focal length of the lens, the aperture used, and the focused distance. In the foregoing I explained these three ideas—focal length, f/stop, and focusing—so we can step to a higher level.

The light going through the lens is focused in the form of cones. The image is sharpest at the tip of the cones. The sharpest image is produced when the tip of the cone lies on the focal plane. Only a point at the focused distance lies at this tip. Other points produce cones with tips lying in front of or behind the focal plane. The focal plane intersects these imaginary cones, therefore instead of points, smaller or greater circles are produced as the projected image of a point in nature. If the diameters of these circles are smaller than the standard of sharpness, we accept the image as sharp. The photographic term for these intersected cones (and the tip of the cone also, since an absolute point exists only mathematically) is "circle of confusion." When we use a large f/stop the cone is thick, so the intersection has a large diameter that may fall beyond the accepted standard of sharpness. As we close the diaphragm, the cone becomes narrower. Finally we reach an f/stop where the cone becomes so thin that the diameter of the intersection hits the accepted standard.

These conditions result in the fact that short-focus lenses produce a greater depth of field than longer-focus lenses because of the smaller actual exit diameter of their relative apertures. More-

16

over, the axial movement of the tip of the cone is necessarily much more limited when a short-focus lens is focused for different distances.

The smaller axial movement of the cone explains why depth of field is greater when a lens is focused for greater distances than if it is focused for closer distances at the same aperture. This means that the actual length of cones of more distant points does not differ too much in comparison to the distance differences. But, on the other hand, little distance differences of close points, lying one behind the other, result in a relatively great change of the length of their cones when we focus the lens for these distances. So it is a great possibility that the tips of the cones are thrown so far in front of or behind the focal plane that the diameters of the intersections in the focal plane are greater than the accepted standard of sharpness.

Summing up: Depth of field is the ability of a lens to yield a certain zone of acceptable sharpness beyond and in front of the focused plane. The extension of this zone depends upon the focal length of the lens, the diaphragm opening, and the focused distance. As a fourth component you should know that at medium focusing distances the sharp zone extends in front of and behind the focused plane in a ratio of about 1:3 to 2:3.

The conscious regulation of depth of field is done through the selection of the proper f/stop. A depth-of-field scale engraved on the barrel of the lens indicates the f/stop and focusing distance for achieving a particular depth of field between two previously determined points. The regulation of depth of field is an essential point of photographic performance. By its use you may point out subject matter, throw disturbing backgrounds out of focus, and achieve a three-dimensional effect.

Subject movement

When we regulate depth of field by selecting a particular f/stop, we have to change the shutter speed also, in order to maintain a proper exposure. But certain limits to our adjusting of exposure exist; we cannot do this without restriction. One limitation is set by the subject's movement. Fast-moving subjects require a short exposure time. But beyond this principal rule some other circumstances have to be taken into account when determining shutter speed, or when calculating whether the shutter speed required by the predetermined f/stop will match the needs of the subject. What

17

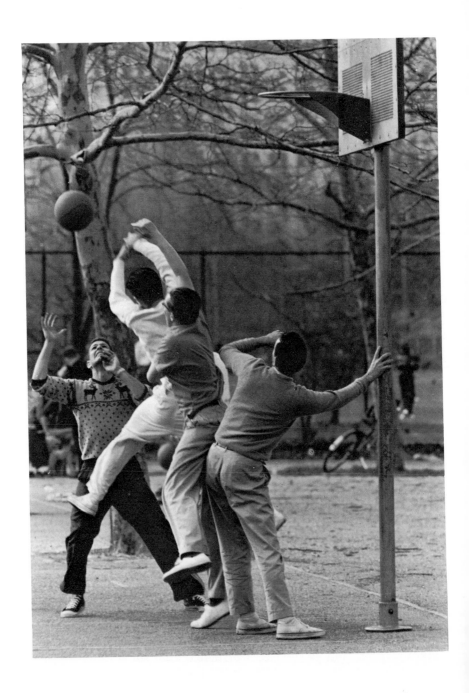

The shutter speed has to be determined by the speed of the action. This shot was taken at 1/1000 sec.

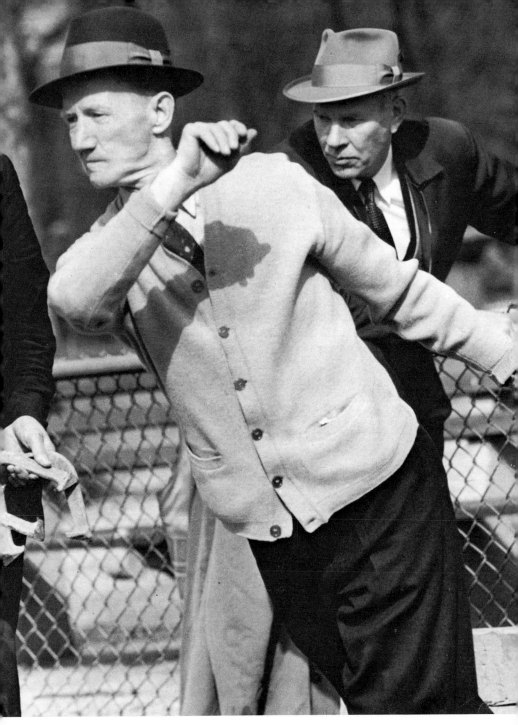

The subject had no linear speed, but the swing of his arms required a fast shutter speed.

circumstances may change the necessary shutter speed which has been determined by the speed of the subject? First of all, the direction of the movement plays an important role in the selection of the shutter speed. Then comes the distance of the subject from the camera lens, a factor related to the focal length of the lens. For instance, when we determine the shutter speed for a moving object 100 feet way, and we are using a 200mm lens instead of the 50mm normal lens, we have to make our calculation as if the subject were only 25 feet away from the lens. And when we have set all the necessary calculations, the possibility of camera jar arises as another factor which has to be taken into account. The slower the shutter speed, the greater is the possibility of unsharpness due to camera movement. This possibility increases in direct ratio to the focal length of the lens. It is fortunate that great depth of field is not always required, so we can maintain a short enough exposure time to decrease the effect of camera jar. When we do need great depth of field, the speed of modern films allows us to stop down the diaphragm without sacrificing too much of the security of a fast shutter speed. The bottom level of this security depends on the focal length of the lens and upon the camera support. As a general rule, you have to seek as steady a support as possible even with short exposure times, or at least lean against something at the instant of exposure, and hold your breath when you press the shutter-release button. If you can't find any support for the camera, 1/100 sec. is sufficiently fast to prevent unsharpness due to camera jar when a normal or wide-angle lens is used. When a 135mm telephoto lens is used, greatest care has to be taken even at 1/250 sec. The necessity of care increases and the necessary exposure time is shortened

Blurred motion gives a feeling of action to the photograph.

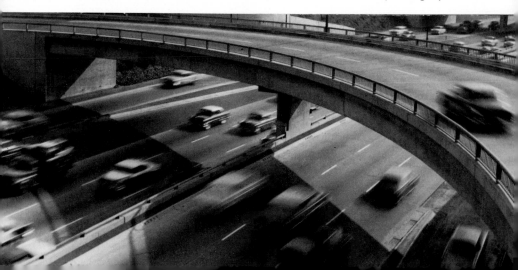

when a 200mm lens is in the camera. No exposure is possible without sturdy support when the lens reaches the 300mm mark.

Light intensity and film speed

As you learned from the foregoing, several components play roles in determining an f/stop-shutter speed combination, but all of these components are necessarily combined with two more factors; namely, with film speed and light intensity. Now that we are familiar with two of the four partners that determine the exposure, let's become better acquainted with these last two fellows.

First of all, I would like you to learn about one of the most vital ingredients of photography, light intensity. This varies—as you can imagine—over a wide range and it can be easily measured with photoelectric exposure meters. When an exposure meter is adjusted to a given film speed, its readings are automatically, but only approximately, correct. (I will explain the evaluation of an exposure-meter reading later. For the time being let's suppose the exposure meter indicates a perfectly correct exposure, as in certain cases it may.)

This exposure sets off invisible traces, or more exactly, changes, in the construction of the light-sensitive layer of film. These invisible changes form what is called the latent image, which will be developed into a visible image during processing. Going back to the discussion of light intensity, how does this affect the latent image?

As I mentioned, the exposure meter has to be adjusted to the film speed. It should be obvious that this has something to do with light sensitivity. As you may suspect, when you hear the term "film speed," different kinds of film are available to match different conditions of light intensity. So, when using the proper film, you almost always can secure sufficient and proper exposure within the limits of tolerable f/stops and shutter speeds. Tolerable, in connection with shutter speed, means that you have sufficient shutter speed to eliminate the hazard of subject or camera movement. As it applies to the f/stop, tolerable is taken to mean one of those f/stops that can be used with the shutter speed you have selected.

For dim light conditions we use fast films and for bright light conditions (or for special purposes) we can use slow films. Between the two extremes we use medium speed films. I can assure you that most photographic situations can be handled easily with medium-speed films. In any case, your exposure meter can tell you when

21

you are exceeding the limitations of the film loaded in your camera. Thus, it can tell you that your camera does not have a short enough exposure time or a small enough f/stop necessary to take pictures in bright sunshine on the beach or in the snow, when a high-speed film is loaded into your camera. On the other hand, your exposure meter will surely indicate that the greatest aperture of your lens is not great enough to take photographs at night on the street or in any other dimly illuminated place (without risking camera or subject movement) when your camera is loaded with a film of low sensitivity.

The speed of films is indicated by numerals: the ASA exposure indexes. These are arranged in such a way that halving or doubling the numeral indicates an exactly halved or doubled speed value. For example, a 400 ASA film is twice as sensitive as a 200 ASA film, and a 100 ASA film has only half the sensitivity of 200 ASA film and only a quarter of that of 400 ASA film.

The films are arranged according to their speed into three groups:

Slow films—to 50 ASA.
Medium speed films—50 to 200 ASA.
Fast films—over 200 ASA.

Although the ASA exposure index is the best known characteristic of a film, there are other features which may determine whether one film or another should be used in a certain situation. Generally, these other features are closely connected with the film speed; such as the graininess, the resolving power, and, sometimes, the gradation.

Films of the low speed group excel in the finest grain structure and resolution, but most of them show a tendency to be contrasty.

Films of the high speed group obviously have a coarser grain structure and decreased resolution (to tell the truth, some of them do not differ too much from films of the medium speed group; they are really excellent) and they are likely to produce a soft negative.

Today's medium speed films approach the small grain structure and resolving power of the low speed films and the light sensitivity of the high speed group. Thus, I can state that they are adequate for almost every picture taking situation. Their gradations differ by make, and one may select the preferred one; however, let me suggest that it should be rather on the soft side, because in 35mm photography, a soft negative is preferred.

Summing up: Speed, grain structure, resolution and gradation are the most important characteristics of a film, and all these fea-

tures are related to each other, as well as to the manner of processing; namely to the choice of developer and the developing factors (time, temperature and agitation).

But, before I deal with processing, I would like to discuss another feature of films: the color rendition.

Color rendition of films

In the early days of photography light-sensitive materials were color blind. That is, the photographic plates registered only a narrow strip of the spectrum in the blue area. Later, when sensibilitors were invented, the color sensitivity of films extended over the entire visible spectrum. Films that are sensitive over this range of colors are called panchromatic. The only trouble was that an excess in blue sensitivity remained and it could not be depressed to a level comparable to the eye's rendition of the dark-light relationship of different colors. Therefore, white clouds disappeared from the sky if the blue of the sky was not deep enough. To solve this problem, filters, which cut off a certain part of blue light rays, have to be used. Filters of complementary colors can do this job, and the denser the filter, the more blue is held back.

Orange is the complementary color of pure blue. But adjacent colors, such as yellow and red, are used in the same way to cut excess blue (more exactly, short-wave colors), since the blue sky contains not only a narrow band of pure spectral blue, but a mixture of other adjacent wavelengths as well. So, the effect of the filters depends upon the saturation of the blue. A darker filter has to be used as the amount of blue in the mixture decreases. The efficiency of filters starts with light yellow and goes up to dark red. Red is the most effective filter for cutting off excess radiation, because the basic blue of the sky is likely to be mixed with green. So the red filter—besides its great blue-effective orange content—is able to bridle another strong component of the mixture. Since filters cut a certain amount of light out of the minimum exposure required by the film to build up the latent image, this missing amount has to be compensated for by increasing the exposure, either by opening the diaphragm or by using a slower shutter speed. How large the increase should be is determined by the so-called filter factor, which is engraved on the mount of each filter or printed in the instruction sheet packed into the box of the filter. Simply, you multiply the already determined exposure by the filter factor and you have the new exposure. For example, if your exposure reading was $f/8$ and

The red filter was used to separate pink flowers from the sky effectively.

1/500 sec., and the filter factor is 2, either you have to open the diaphragm one full stop to $f/5.6$ or set the shutter speed dial to 1/250 sec.

Sometimes the filter factor is not a whole number, but a fraction, say 1.2, or 1.5. In these cases you can only regulate the diaphragm, because you can set the aperture anyplace between the full $f/$stops, but cannot set intermediate shutter speeds.

The red filter rendered the blue sky almost black.

Filters are used not only to bring the color rendition of the film close to that of the human eye, but sometimes to change a correct color rendition to an incorrect one in order to achieve an effect.

Since films render color in the gray scale according to their light-dark values, it may happen that two contrasting colors (such as red and green) are reproduced in the same gray tone. Imagine that you take a picture of dark red flowers in front of a green bush. To your eyes the color contrast is considerable, but your film probably reproduces both colors in the same gray tone, so the flowers very likely blend into the background. We can overcome such a situation by using a filter. The kind of filter used depends on which color we wish to darken and which part of the picture is to be pointed out.

Filters basically lighten their own color and darken the complementary color (we must take into account, of course, the effect of adjacent colors, also). So, in the case of the rose we should use a red filter to obtain the same effect in the picture that the conspicuous red provides for our eyes.

The appropriate table in Chapter 9 provides useful information about the effect and use of various filters. I have given you the basis for the use of filters, but don't think that it is always necessary to use a filter. The direction of light often limits the use of a filter (filters are most effective in flatlighted situations), or may even make the use of a filter needless, since the construction of the photograph may be built upon light effect (backlighting). You can learn more about this and other useful techniques in my previously published book, *Guide to Photographic Composition*.

Light direction

Light direction is closely connected with correct use of a light meter. I will now explain this.

To understand why you may not rely upon the readings of your light meter, you have to know that modern films render contrast differences of 1 to 1000, but photographic paper cannot equal this tremendous (10 f/stops) ability of the film to render contrast. The paper can do this only in a ratio of about 1 to 30 (which is about 5 f/stops), although skilful enlarging techniques (dodging and burning in) may extend this limit. Despite this, we may exceed the limits of tonal rendition of photographic paper if we do not judge contrast differences too scrupulously and we determine the exposure by the average reading method, which does not take into account the importance of specific areas. Generally, we do not have

any trouble with average flatlighted situations (except snow), since the contrast of the scene does not extend beyond 5 f/stops. Therefore, when we take an average reading, we keep the exposure approximately in the middle of this 5 f/stop range. But, if the illumination is more contrasty (back- and sidelighted situations), or perhaps the inherent tonal qualities of the scene are beyond the limit of the paper, take close readings of both highlight and shadow areas. Decide which area has to be rendered correctly, and use the exposure that conforms to your decision. If both areas are equally important, expose in between the two values, but this exposure must not be more than two or three f/stops from the lowest reading. If you cannot make a close reading, open the diaphragm one full stop over the average reading if the scene is backlighted. It is a quite reliable method under average conditions to point your exposure meter at the palm of your hand, when it is exposed to the oblique light of the main light source and use that reading. The 1 to 1000 contrast-rendering ability of film is theoretical only, and we cannot make use of it even with the most skilled processing. Moreover, a negative showing too much contrast requires soft paper for enlarging, which is disadvantageous in 35mm photography

Backlighting may produce a pleasing effect, although the tonal rendition may be improper.

In the case of insurmountable contrast differences, exposure has to be determined to render the most important area correctly.

(see *Improved 35mm Techniques*). Therefore, we have to strive to compress the contrast differences of the densities in the negative between limits of 1 to 100 (between 6 and 7 f/stops). Besides the selection of the proper developing methods, we can do this by fill-in light. Take, for example, a portrait in which the difference of the illumination between the two sides of the face exceeds that 6-7 f/stop limit. Then we have to provide for some kind of reflecting surface, or for a supplementary light source which will cast light into the less illuminated area, decreasing contrast to a tolerable level.

Processing

After all 36 exposures (or 20, depending on the length of the film) are made, you rewind the film into the cartridge by rotating the rewind crank (after actuating the film-rewind-release button,

ring, or lever). After this operation (you can hear and feel when the end of the film is released from the take-up spool) remove the cartridge from the camera (this may be done in the light) and start processing.

The processing of films is much easier than many people think, and it is exciting to see the results of one's picture taking as soon as possible. Relatively little equipment is necessary for negative processing: a 35mm developing tank, a thermometer, two plastic funnels, two one-quart plastic bottles (one for the developer and one for the hypo), a one-quart darkroom graduate and a stirring rod.

When mixing the chemicals follow the instructions exactly, especially in connection with the stirring and temperature. Take the greatest care that the developer does not become contaminated with the slightest traces of hypo. During the entire life of the developer you should guard against this, and be especially careful about the clean handling of processing equipment. Mark one funnel with the letter "D," another with the letter "H" or "F" (fixer). The plastic bottles (one should be brown, for the developer; the other white or another color) should be marked with 1½-inch long strips of white adhesive tape with the date of mixing written on them. Leave enough space on the tape of the developer bottle for additional markings as records of how many times the developer has been used. These records are unnecessary for the hypo bottle, since you pour out the hypo when the developer is exhausted.

The degree of exhaustion of the developer is an important factor in determining the necessary developing time (unless you use a one-shot type developer). The instruction sheets of most developers indicate the prolongation-factor which has to be applied for repeated use of the developer. It is advisable that with the help of this factor you calculate in advance all the individual developing times due to the exhaustion of the developer and write them in the form of a table, so you can avoid miscalculation in the heat of work. Simply take a look at the markings on the bottle to learn how many rolls were developed in the solution, and consult the table for the necessary developing time of the next film. If you sometimes develop half rolls or 20-exposure rolls, mark this on the bottle as half rolls. Take the developing time in between the numerals of the sequence determined for full rolls, if the sum of the previously developed films does not come out as a full number of rolls.

The maintenance of the recommended temperature during the entire developing time is as important as the developing time itself. Since developing time and temperature are interconnected in producing a certain negative contrast, slight changes of temperature

can be balanced by changing the developing time. The instruction sheets of developers tell us the rate of change of time for each degree of temperature change. If the instruction data does not contain accurate information on these relationships, you will not be too far off if you increase the developing time 7 per cent for each succeeding roll (if one quart of solution was mixed), and decrease the developing time 2½ per cent for each degree of temperature increase or vice versa. You may develop about ten 36-exposure rolls in most one-quart solutions of developer.

Agitation is the third factor in maintaining proper negative contrast. The instruction sheet contains directions for this, also. For obtaining constant results, these directions have to be followed accurately and uniformly for each film processed. After you become more experienced in judging negative contrast you may deviate from the recommended manner of agitation and develop your own method (you may agitate for 5 seconds in each minute instead of the recommended 30-second intervals). In this way you may control negative contrast, and determine the preferred one.

After you pour the developer back into its container, rinse the film for about one minute in plain water or in the recommended stop bath. (To avoid reticulation the temperature of water should not differ more than 5° F from that of the developer. This 5° F tolerance has to be maintained during the entire processing.) I personally prefer the plain water bath, because I consider the after-developing action on the shadow areas due to the increased exhaustion of the developer in the highlight areas during rinsing. This effect cannot be obtained when a stop bath is used.

The cover of the developing tank is still on, and you can open the tank one minute after the hypo is poured. Do not extend the time of fixation too much beyond the recommended time, because fine details of shadow areas may be reduced. On the other hand, do not take the film out of the hypo before the recommended minimum time, because this will cause insufficient washing. Fixation is not fully finished when the milky appearance of the film has disappeared. Further and invisible transformations of silver salts take place after clearing of the film, which takes about double that time necessary for clearing the film; only this secondary silver-compound may be washed out of the film by water.

The next step of processing is washing the film in running water for about 30 minutes. Watch out again for the temperature of the water. You can shorten washing time by using a commercial hypo neutralizer. You may prepare such a solution yourself instead by

dissolving 30 grains of sodium carbonate in one quart of water. During washing agitate the reel several times to disperse the accumulated bubbles on the film. At the end of the washing give the film a final and strong rinse by rotating the reel under the rubber pipe, causing direct rinsing of the entire surface of the film by a strong jet of water. Shake down excess water and put the reel into Photo-flo or some other wetting agent for about 30 seconds. Afterwards take the film very carefully out of the reel, and hang it up to dry. Immediately after you hang up the film, moisten your fingers with the wetting agent and squeeze down the film between your second and third fingers to avoid drying marks. One pint of wetting agent solution should be mixed at the same time that other solutions are mixed, and discarded when they are discarded.

The wet and sticky gelatin is likely to pick up dust from the air during the drying period. Therefore, avoid any kind of movement in the room where the film is drying, since this surely would stir up a lot of dust. In any case, the soft gelatin may be invaded very easily by any kind of foreign object, not only during the drying period but during the other steps of processing also. Therefore, all the processing solutions have to be filtered, by putting a cotton wad into the funnel when the solution is poured into its container after mixing. Used solutions have to be poured out carefully from their containers when you develop film to avoid stirring up ever present sediments. In some cities the water contains rust and other foreign objects which may get into the gelatin during washing. In such cases an efficient filter has to be used at the end of the rubber hose which leads the water to the film. If we do not take greatest precautions for minimizing settlements of dust and dirt onto the surface of the film, nervewracking spotting work on the print will be necessary, since an invisible spot of dust on the film will blow up to a very conspicuous white spot on the print, due to the great degree of enlargement necessary in 35mm work. It is fortunate that modern films have such a thin emulsion that they dry in about 10 to 30 minutes, depending upon humidity conditions. (Don't expect your film to be dry in 30 minutes when the humidity is 96 per cent.)

The dry film is also a good target for dust, and must be taken down as soon as possible. But, before filing, roll the film, emulsion side out, and put it into an empty bulk film drum for about 24 hours. In this way the tendency of the film to curl is reduced, and it is easier to cut the film into 5 or 6 frame pieces when filing strips if they are flat. Moreover the danger that Newton-rings will form is

minimized. This phenomenon appears in the form of rainbow colored circular spots, if a glassless negative carrier is not used in the enlarger, or if the condenser is used in close contact with the film to hold it flat during enlarging. The effect of Newton-rings is plainly visible on the print and cannot be retouched. Its appearance cannot be eliminated easily, once it occurs between the film-glass contact.

Several methods are used for filing negatives. The most popular method is to put the film strips into individual glassine envelopes. It protects the film completely from dust, dirt, and fingerprints. Meanwhile you can take a look at the film without removing it from its envelope, to select the needed frame for enlarging.

2

ngle-Lens Reflex
;. Rangefinder

As one might assume from the foregoing, there are two basic
es of Canon cameras: the single-lens reflex type (in the follow-
I will refer to this type, for the sake of brevity, as SLR) and
rangefinder type (in the following referred to as RF). Since
are getting acquainted with most of the basics of photography,
ill take you one step further through an examination and com-
ison of the features of both camera types. This examination will
ng to light the practical terms and experiences of the specific
d of 35mm photography. And during this examination I will try
give an objective appraisal of the advantages of both camera
es, in order to help you to realize the possibilities and limits of
r tool. I shall conduct this examination by a comparison of the
cific controls of each camera type, and how these camera types
ave toward some phenomena, photographic rules and practices,
under different conditions.

Rangefinder Cameras

First of all you have to learn more about the rangefinder Can-
. Their common basic features are: focal plane shutter with
eds from 1 to 1/1000 sec.; interchangeable lenses from 19mm to
0mm focal length with Leica-type thread mount (up to the
mm focal length the lenses are coupled to the rangefinder, over
focal length the Canon Reflex Housing should be used). The
gefinder is a coincidence type device and its eyepiece is com-
ed with the viewfinder. The viewfinder itself shows the fields of
w of five different focal length lenses. The execution of this very
ful feature is different in the various models.

The manner of the film advance is also different in the vari models, but the effect of activating the lever, trigger, or knob is same in all the models: advancing the film, cocking the shutter, advancing the film-counter dial.

Built-in flash and speedlight synchronization are also comr features. An accessory shoe is located on the top of each model, a unique automatic parallax compensation device is incorpora in the accessory shoe of models V and VI.

Six models of Canon RF cameras are available in this coun The Model IVS2, which is the highest development of the ear conventional models, the Canon V, the Canon VI, the Canon P (F ular), the Canon 7, and 7S. These models represent a comp deviation from the conventional design and incorporate a num of unique features in their construction.

In the foregoing I described the common basic features of th various models. Now I would like to discuss the differences betw them, or how those common features were executed technically the different models.

Opening of the camera is effected in the IVS2 and in its pre cessors by a removable baseplate. The V, VI, 7, 7S, and P hav hinged back.

The film transport and coupled actions such as shutter cock and advancing the frame-counter are done with a knob on the of the camera in the IVS2 and the previous models; with a trig on the baseplate in the V and VI (the manual film-winding kno also found on the top in these models), and with a lever in the 7, and 7S models.

The frame-counter dial returns automatically to the start position when the camera back has been opened in models VI, 7, and 7S, but this has to be done manually in all the other mod

The Canon VI, the Canon P, the 7, and 7S have a single n rotating shutter speed dial; while the Model V and the earlier o feature a rotating dial on the top of the camera for speeds f 1/1000 to 1/60 sec., B, and X (this is the mark for speedlight s chronization, if any, in the earlier models), and a slow-speed from 1/30 to 1 sec. and T on the front of the camera.

The viewfinder shows many changes throughout the devel ment of Canon cameras. The earliest models, up to the Model S, a pop-up, separate viewfinder. Only after World War II were viewfinder and rangefinder combined.

Canon was the first to introduce the multifocal viewfinder. Canon IVS2 has an indicator under the film rewind knob that be set for the use of 50mm, 100mm, and 135mm lenses. The Ca

34

as a three-position viewfinder also, activated by a notched wheel
de the eyepiece. On the top of the camera is a dial that shows
ther the viewfinder is set for the 35mm, 50mm, or 100mm lens
e field of the 100mm lens is marked by a luminous frame within
field of the 50mm lens), or it shows a magnified image to ease
focusing (RF position).

The Canon VI has the same three-position range-viewfinder se-
or (a fourth was added to the Canon 7 and 7S), but they are im-
ved by automatic parallax compensation. Any luminous frame,
cted by the dial, is adjusted when the lens is focused. Besides
kind of parallax compensation, an automatic parallax adjust-
t pin is built into the accessory shoe which bends the accessory
er while the lens is focused, and in this way the parallax adjust-
t is automatic when this kind of finder is used. The Canon
lso features this parallax adjustment pin; however, the built-in
vfinder does not compensate for the parallax. In the Canon P
situation is reversed, because there is no pin, but the luminous
nes are coupled to the rangefinder focusing. However, these lu-
ous frames cannot be changed by a frame selector, as they can
n models V, VI, IVS2, 7, and 7S, so that the fields of the 35mm,
m, and 100mm lenses are constantly visible in the view-range-
er eyepiece.

Focusing is eased by the magnified image due to the RF position
he frame selector or the 1.5 position of the indicator lever in the
on IVS2 and some earlier models. Focusing can be done by any
tion of this device, of course. Since the Canon P does not fea-
a frame selector we have to be satisfied with the life-size image
he range-viewfinder instead of a magnified one.

The rangefinder itself is a short-base prismatic type. The short
allows moderate moving of the image during focusing. This
ure has been proved good in the Leica and similar cameras also
asily bringing the two images, seen in the middle of the view-
gefinder field, into coincidence.

Once the lens is attached to the camera, it is automatically cou-
to the rangefinder mechanism. All the screw-mount lenses
non, Leica, and others) fit into (and couple to the rangefinder)
Canon body. Moreover, they can be used with the SLR Canons
using the appropriate focusing adapter in combination with a
head adapter.

The Canon V, VI, P, 7, and 7S models are provided with a self-
er as well as a film-speed reminder. This device is present in the
ier models also down to the Model III-A.

Rewinding the film is done in the Canon VI and P by a le
and in the Canon V, IVS2 and earlier models by a knob.

The curtains of the focal plane shutter of the Canon VI, 7,
and P are made of metal. All the other Canons have cloth f
plane shutters.

Since you are now acquainted with the typical features
rangefinder camera, I can start with the comparison of the
systems.

It is most appropriate to examine the viewing systems first
course, since lens interchangeability is related to the viewing
tems, I will examine the systems from this viewpoint.

Viewing System

The newer types of Canon RF cameras, such as the Canc
and 7S, have an adjustable built-in finder that features bright I
parallax-compensated frames for five focal lengths, 35mm, 50;
85mm, 100mm, and 135mm. For any other focal length betw

The luminous frames seen in the range- and viewfinder indicate
field of view of three Canon lenses—35mm, 50mm, and 100
During focusing, these frames slide diagonally and compensate
parallax.

m and 135mm an individual finder or one of the Canon Uni-
al or zoom finders has to be used. Of course, these finders are
illax compensated also. Perhaps I should take time here to
lain parallax.
Parallax is the result of the different vantage points of the lens
 the finder. It often causes inexperienced photographers to cut
the heads of persons in pictures. Since the built-in luminous
ne finders and all the supplementary finders are coupled to the
gefinder mechanism of the Canon, parallax correction is auto-
ic during focusing. We do not have to worry about uninten-
al surgery. But we have another kind of parallax which cannot
compensated by the sliding luminous frames or by the tilting
ers. This is called depth parallax. You will understand this idea
n I describe briefly how automatic parallax compensation
ks.

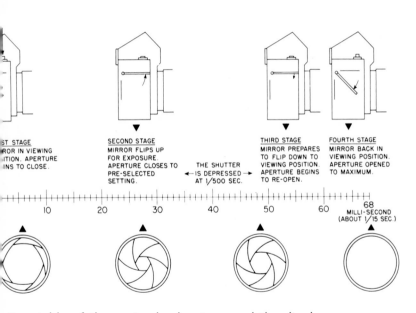

ST STAGE	SECOND STAGE		THIRD STAGE	FOURTH STAGE
ROR IN VIEWING	MIRROR FLIPS UP		MIRROR PREPARES	MIRROR BACK IN
ITION. APERTURE	FOR EXPOSURE.		TO FLIP DOWN TO	VIEWING POSITION.
INS TO CLOSE.	APERTURE CLOSES TO	THE SHUTTER	VIEWING POSITION.	APERTURE OPENED
	PRE-SELECTED	←─IS DEPRESSED─→	APERTURE BEGINS	TO MAXIMUM.
	SETTING.	AT 1/500 SEC.	TO RE-OPEN.	

10 20 30 40 50 60 68 MILLI-SECOND (ABOUT 1/15 SEC.)

time-table of the spring-back mirror and the diaphragm.

Simply, when we focus the lens, the axis of the viewfinder, due
 he effect of the tilting mechanism coupled to the rangefinder,
ts the axis of the lens at the focused plane. Therefore, the frame
jected by the lens is identical with the frame seen through the
vfinder, but only at the focused distance. Since the axis of the
er is tilted in relation to the axis of the lens, we cannot see

identical framing behind and in front of the focused distance. '
fault causes trouble when exact depth composition is necessary
often causes disappointment even in less critical cases, simply
cause the finder cheated us when we selected a certain line or fi;
composition into the depth through the finder. In this case the v
ing system of the SLR is much more reliable. No parallax ex
because the image viewed in the finder is identical with the in
projected by the lens.

Continuous observation of the subject, and the bright im
independent of the lens aperture used, was a great advantag
RF cameras over the SLR. But the introduction of the inst
return mirror, and the completely automatic features of the C:
lenses, eliminated this drawback. The entire automatic cours
various operations during exposure in the SLR starts with dep»
ing the shutter button and is finished within the inertia time of
eye (see the diagram).

Focusing System

Although the focusing and viewing systems are unified in
Canon made cameras, I have to examine them separately, du»
their different functions. Most RF Canons have literally two k
of focusing. One is incorporated into the normal image in the v
finder, the other is for critical focusing, yielding a greatly ma
fied rangefinder image when the view selector is turned to the ".
position. In both cases focusing is very easy, unambiguous,
independent of the focal length of the lens used.

However, it is almost impossible to follow approaching or
parting objects continuously and keep them in focus, as we
able to do with the SLR. With RF Canons we have to prefocu»
a certain spot on the presumed course of the moving subject,
release the shutter when the object reaches this spot. Of cou»
we can make use of depth of field, and if we stop down the
aperture sufficiently, we do not have to worry about unsharp»
caused by the subject's running beyond the sharp zone. We do
prefocusing by measuring the closest and the farthest points on
presumed course of the subject between which we would lik»
catch the subject—allowing some safety space—and with the I
of the engraved depth of field scale, we determine the necess
f/stop and the distance to which the lens has to be focused.
course, the shorter the focal length, the larger the lens aper»
that can be used, due to the greater depth of field offered by
shorter focal length lenses.

38

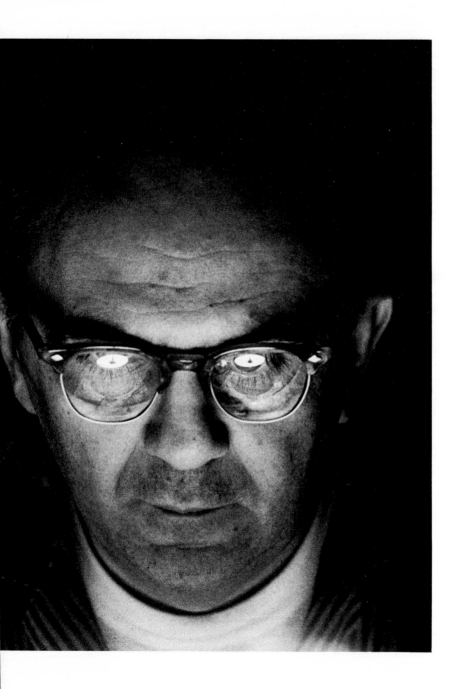

proper setting of light spots in eyeglasses can be realized only
he viewing system of an SLR camera.

The wide-angle lens can be used to achieve unusual proportio
renditions.

This method can be followed with a single-lens reflex cam
also, especially when a wide-angle lens is used, because quick cr
cal focusing is quite difficult in this case. This difficult focusing
wide-angle lenses with an SLR does not present too much of a dr:
back, since we may rely upon the great depth of field, which eli
nates some mistakes in focusing. On the other hand, when l
focus (or even normal) lenses are used, the shallow depth of fi
of these lenses makes the focusing quite easy with an SLR, es
cially when we can do this with full lens aperture, which clc
down to the preselected f/stop automatically when the shutter
released.

When I started using the first pentaprism SLR camera av
able shortly after World War II, not even the preset diaphra
had been invented. The preset diaphragm made things somew
easier, but a great time lag still existed between focusing and sh
ing. Many times I disregarded the preset ring and I had to fo
with a stopped down lens. It was a good thing that for dayli

40

ditions (and for achieving fine grain) 40 ASA films were used,
that we could not stop down the lens as much as we do now.
erefore, it did not make too much difference in focusing that
re was a two or three f/stop difference between the full aperture
the aperture used.

Nowadays we use much faster films (with the same or perhaps
ter grain quality), and we stop down the diaphragm two or three
litional f/stops (a difference of about 4–6 f/stops over the great-
aperture of f/1.8 or f/2) under average conditions. The depth
field is so enlarged that critical focusing becomes almost impos-
le, and the entire image viewed in the finder so dark that we
not see important details, say expressions of faces. Therefore,
introduction of the automatic lenses meant a tremendous im-
vement in the focusing system of the SLR. We can focus with
se lenses at full aperture, and we see a light, easy-to-recognize
ge, with a shallow depth of field. Focusing is thus as easy and
urate as with the rangefinder. Then, when we actuate the shut-
release button, the diaphragm automatically closes down to the
selected f/stop. After the exposure, the diaphragm reopens to
aperture again. The checking of the depth of field can be
ieved if the so-called A-M ring is turned to the M (manual)
ition. Then the lens is stopped down to the preselected f/stop.
er that you turn the ring back to A (automatic) position. The
ghtness of the viewing-focusing system is greatly enhanced by
use of a fresnel lens. In the middle of this fresnel lens is a mi-
prism for focusing.

Use of Long Focus Lenses

As the basis of examination, three viewpoints have to be taken
o consideration: the accuracy of focusing, the visibility through
finder system, and the limits of focal length used under average
ditions.

Since the 135mm lens is the longest lens that can be coupled
the rangefinder of the Canon (or any other camera), this is the
it that can be set in the light of these examinations. The su-
iority of the SLR system is obvious when lenses of longer focal
gth are used. Although mirror-reflex housing is available for
cameras for use with longer lenses, the originally mirror-re-
ced camera is a more advantageous solution than the separate
rror-reflex housing. And when a 200mm Canon lens is used in

Canon SLR we can enjoy all the automatic features of the ‑anced SLR system. On the other hand, when a 135mm or 100mm ₃ is used with the mirror-reflex housing on the Canon for the ‑e of parallax-free performance (depth parallax), automation ₁ot available. So, the mirror-reflex housing cannot replace the R camera, and it cannot produce the same conditions. Thus, the ₁mm focal length is the limit at which RF cameras can be used ‑h equal ease as the SLR under average conditions.

Of course, when the camera is used for special purposes and is ₁nted on a tripod, as for macro photography, or long-distance ‑tography, or for time exposure, it does not make any difference ‑ther the lens is used with a mirror-reflex housing or with an R camera.

Critical focusing for close distances (within 10 feet) seems to ‑easier with the rangefinder than with the mirror-reflex, since ‑e is no doubt of the coincidence of the superimposed images of RF system. The consideration of sharpness can always be a ‑tter of subjective feeling when using the SLR. As the distance ‑eases this gap becomes inverted in favor of the SLR, since the ‑e of the rangefinder (the distance between the two windows of rangefinder) is tiny in relationship to the distance to be meas‑d. I could say that the depth of field of the rangefinder is too ‑at to allow accurate focusing at over 30 feet.

It is lucky, as you learned in the discussion of depth of field, ‑t the depth of field of lenses increases as the focused distance ‑eases. This increased depth of field eliminates the limited per‑mance of the rangefinder at greater distances. So you do not ‑e to worry about unsharpness of the subject. But you can worry ‑ut the limits of the sharp zone of the depth of field if the lens ‑ither focused to a close or to a farther distance. We can see this ‑e in the ground glass of the SLR. When I focus on the eye of a ‑son, I am not sure whether the person's ears will be sharp or ‑ when I use an RF camera; but I can actually see it when I use ‑ SLR camera. I have to point out this depth of field problem, ‑ause the longer the focal length of the lens, the shallower is ‑ zone of sharpness. Certainly, it is very easy to slip into total ‑harpness if continuous visual control is not available.

longer the focal length of the lens, the shallower the zone of ‑rpness. In this case the 135mm lens was used.

se photos of the same
ne, taken from the same
tage point, demonstrate
field of view of five Canon
es: 19mm, 35mm, 135mm,
mm, and 400mm.

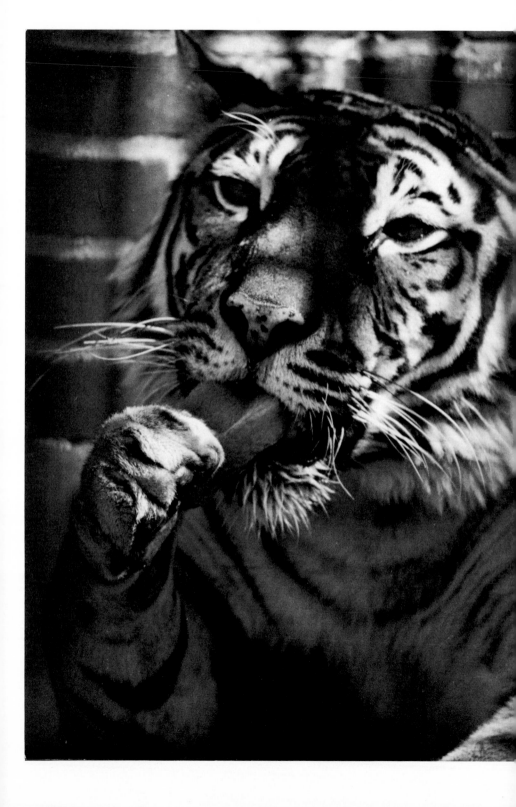

Therefore, most photographers prefer the SLR system when
ng long-focus lenses. The magnified image of the telephoto lens
 makes the SLR popular for use with long-focus lenses. In-
ased visibility and the possibility of observation of the magni-
image produced by the through-the-lens viewing system is de-
ble as opposed to the small image of some accessory finders used
h a 135mm lens. When the subject is further than eight feet
ay, the expression of the face is not recognizable through the
essory finder. And I do not have to say that when we exceed
135mm limit quite a new world is projected onto the ground
ss of the SLR, such a world as we cannot even notice with our
ed eyes, giving new aspects for picture taking. The conclusion
then, that the RF system cannot compete successfully with the
R system when long focus lenses are used.

Use of Wide-Angle Lenses

The same viewpoints have to be taken into consideration here
for the use of the long-focus lenses. However, I will examine
e other features also.
Because of the increased depth of field of short-focus lenses, fo-
ing presents some difficulties for the SLR, even one with a fully
ned diaphragm. In this area the RF camera beats the SLR. But
RF camera beats the SLR only theoretically, because the in-
ased depth of field actually eliminates also the differences caused
less accurate focusing, especially when we use a small f/stop
8 is a small aperture for rendering a great depth of field with a
le-angle lens). However, some people are unable to focus a wide-
le lens in an SLR camera, or feel uncertain if they cannot visual-
exactly the change of distances. For these persons I recommend
ging the distance, or using the predetermined depth-of-field
thod. This method is very useful in RF focusing also, since
re is sometimes no time for focusing. The predetermined depth-
field method makes use of the great depth of field (even at me-
m f/stops) of the wide-angle lenses. These medium f/stops (be-
en f/5.6 and f/11) allow a sufficiently short exposure time

200mm lens not only brought the tiger in almost close enough
touch, but threw out of focus the iron bars between the photog-
her and the animal. To achieve this I used the lens fully open (to
rease depth of field) and leaned as close to the bars as possible.

The predetermined depth-of-field method is often useful when the movement of the subject takes an irregular course and focus cannot be estimated in advance (above).

The wide field of view of the 28mm lens permitted the photographer to capture the central action and complement it by recording the onlookers as well (opposite page).

under average daylight conditions and with medium fast films (100–200 ASA). It is easy to select a sufficiently large depth of field with the help of the depth of field scale engraved on the lens barrel. Perhaps you will be surprised when you look at the depth-of-field scale and you realize that a 35mm lens at $f/8$ and focused for 20 feet yields an extension of the sharp zone from about 9 feet to infinity; and at $f/11$, focused for 9 feet, the sharp zone is between 5 and 35 feet.

Both finder systems give a clear, light image (due to the full-aperture viewing of the automatic system in the case of the SLR), although the image is somewhat smaller than life-size in both cases.

At present, 19mm is the shortest focal length available for both SLR and RF Canon cameras. The 35mm, however, is the preferred and the most often used focal length among wide-angle lenses. We use shorter focal length lenses only for special purposes, exaggerated perspective rendition, or for tricky depth composition.

A drawback of using wide-angle lenses with an SLR camera is that the lens is more bulky than its RF counterpart, because only the retrofocus type construction can be used.

3

Introducing the Canon Cameras

I will assume that you have read already the instruction manual for your newly-purchased Canon camera, so I will not repeat that material here. In the forthcoming chapters you will find information about Canon cameras, about photography in general, and the kind of useful hints that can not be found in any instruction manual. In the course of this process, however, I may repeat intentionally some things from the instruction manual, not only to refresh your memory, but also to pinpoint the correct execution of certain handling procedures, which, if done otherwise, may end up in failure.

Moreover, I am supposing that you already have read in a brochure the description and the main features of your camera. I have the feeling, however, that this book would be incomplete if I did not introduce the reader to the various models and types of Canon cameras, lenses, and accessories currently in production, as well as those recently discontinued. When I mention discontinued products, I will inform you if and how they can be used with current products and vice-versa. This will apply mainly to lenses.

Canon F-1

The most advanced among the Canon single-lens reflex cameras is the Canon F-1. The interchangeability of various parts makes this camera very versatile. The FD series lenses have been developed especially for this camera, thus enabling one to use the through-the-lens meter with the aperture fully open. The FL series lenses allow stopped-down metering. Both types of lens, of course,

51

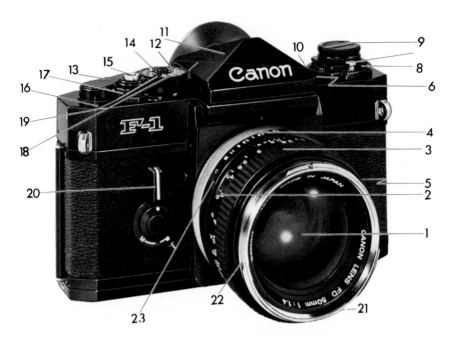

Canon F-1 Camera with FD 50mm f/1.4 Lens

1. Canon lens FD 50mm f/1.4
2. Distance scale
3. Focusing ring
4. Bayonet mount ring
5. Servo EE Finder Coupling Socket
6. Light-taking window for meter information
7. Safety stopper
8. Accessory shoe
9. Film rewind crank
10. Film plane indicator
11. Interchangeable pentaprism
12. Shutter speed dial
13. Film advance lever
14. Shutter speed coupling pin
15. Shutter release button
16. Frame counter
17. Time lock/shutter lock lever
18. Film speed set ring
19. ASA film speed scale
20. Stopped-down functioning/ self-timer lever
21. Coupling pin to speedlight
22. Bayonet ring for cap and hood
23. Pre-set aperture ring

work automatically. This means that when the shutter is released the lens diaphragm closes automatically from the viewing-focusing aperture (full open) to the premetered aperture, with the metering done through diaphragm fully open, or stopped down. The R series lenses have been developed for the first line of fine Canon single-

lens reflex cameras, the Canonflexes. Since the bayonet mount is the same on all Canon SLR cameras, these lenses, of course, can be attached to the recent models also. But because the diaphragm-closing mechanism in the R series lenses is different from that of the FD and FL series lenses, the diaphragm of the R series lenses has to be closed down manually to the premetered f/stop, before the shutter-release button is depressed. The R series lenses, of course, work automatically when attached to any of the Canonflexes, for which they were originally designed.

The finder system of the Canon F-1 is one of the most versatile of the interchangeable features of this camera. Four different types of focusing screens and four different dioptric adjustment lenses can be attached to each of the five finder systems listed below:

1. The standard pentaprism system, with all the necessary information (f/stop scale, shutter-speed scale, warning marks for improper exposure and out of meter-functioning range, battery check, and fixed dot for diaphragm stop-down metering) visible in the finder.

2. The waist level finder.

3. The speed finder.

4. The Booster T Finder, which extends the range of the exposure meter for extreme low light level metering.

5. The Servo EE Finder, which turns the Canon F-1 into a truly automatic electric-eye camera. Wherever the measuring rectangle of the finder is pointed, the exposure meter instantly presets the diaphragm-actuating mechanism (via a servo motor) to that correct f/stop, which is required by the previously set shutter speed (shutter speed priority method). When you depress the shutter release button, the diaphragm closes down simultaneously to the f/stop that the exposure meter indicated as correct.

The Servo EE Finder adapts the camera for automatic flash control when the speedlight electronic flash unit is used. After setting the film speed, shutter speed, and the guide number, the matching needle determines the correct f/stop. This system works with the FD 50mm f/1.4 and f/1.8 and with the FD 35mm f/2 lenses.

Another outstanding feature of the Canon F-1 is the provision for motor drive either for single-frame exposures or for high-speed photography at three exposures per second. Of course, the possibilities of the motor drive can be best exploited when the long-length roll-film magazine is attached to the camera body instead of the regular camera back. This attachment holds a roll of film of up to 250 exposures.

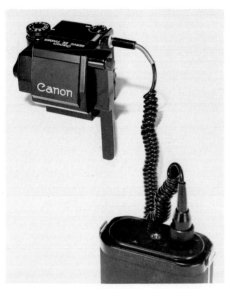

Servo EE Finder.

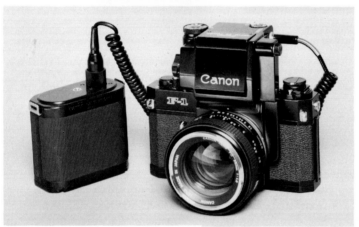

F-1 with Servo EE Finder
and battery.

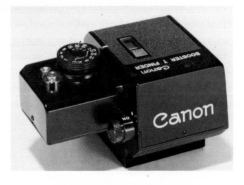

Booster T Finder.

Speed finder (top).

Film Chamber 250 (center).

F-1 with motor drive unit, 250 frame film chamber, Booster T Finder and battery (bottom).

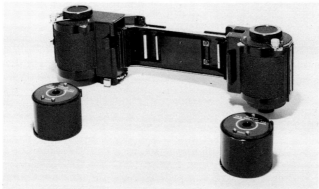

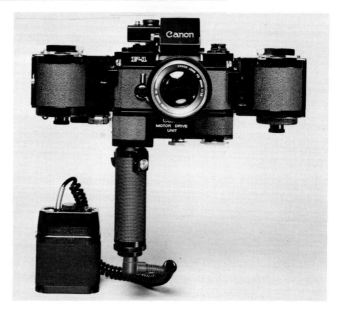

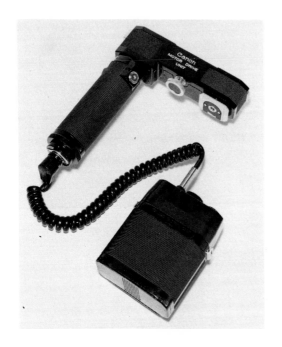

Motor drive unit.

Canon FT, FTb, and TL

The Canon FT and FTb are simplified versions of the Canon F-1. The main differences are that the finder system is not interchangeable, the camera back cannot be replaced by the long-length roll film magazine, and the motor drive cannot be attached. The highest shutter speed is 1/1000 sec. instead of 1/2000 sec.

The difference between the Canon FT and FTb is the way the metering system works. The FT provides stopped-down metering with FL series lenses, while the FTb does this at full aperture when FD series lenses are mounted to the camera, but stopped-down metering only when FL series lenses are attached. In both cases, of course, the diaphragm closes automatically to the premetered *f*/stop. When R series lenses are used the metering is done with stopped-down diaphragm and, after reopening the diaphragm for focusing, the diaphragm has to be closed down again manually to the premetered *f*/stop. The difference between the Canon FT and TL is that 1/500 sec. is the TL's highest shutter speed whereas the FT's highest shutter speed is 1/1000 sec.

Another difference between these cameras is the location of the meter switch, which is at the film-rewind crank on the FTb. The FT uses the self-timer lever for this purpose.

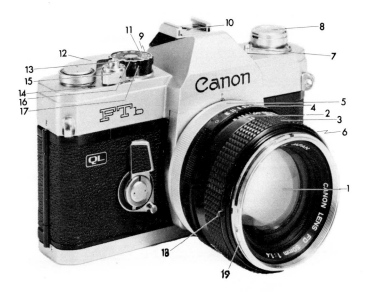

Canon FTb

1. Canon lens FD 50mm f/1.4	11. Shutter speed dial
2. Distance scale	12. Film advance lever
3. Focusing ring	13. Shutter release button
4. Preset aperture ring	14. Frame counter
5. Bayonet mount ring	15. Time lock shutter lock lever
6. Flash socket	16. ASA film speed scale
7. Meter switch	17. Film speed set ring
8. Film rewind crank	18. Coupling pin to speedlight
9. Film plane indicator	19. Bayonet ring for cap and
10. Accessory shoe	hood

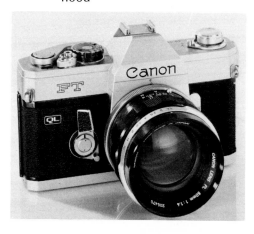

Canon FT.

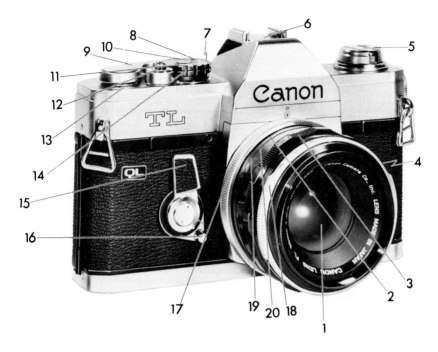

Canon TL-QL Camera with 50mm $f/1.8$ Lens

1. Lens
2. A-M ring
3. Focusing ring
4. Flash socket
5. Film rewind crank
6. Accessory shoe
7. Film plane indicator
8. ASA film speed scale
9. Film advance lever
10. Shutter speed dial
11. DIN film speed scale
12. Shutter release button
13. Frame counter
14. Film speed set ring
15. Metering lever
16. Metering lever lock
17. Bayonet mount ring
18. Preset aperture ring
19. Depth-of-field scale
20. Distance scale

Canon Pellix

The Canon Pellix differs from any other single-lens reflex system by its half transparent, non-moving mirror. This mirror reflects about one-third of the light passing through the lens upward into the finder, while the other two-thirds of the light is projected onto the film plane. When the meter-actuating lever is pushed inward, the CdS cell flips upward behind the mirror and stays one-quarter inch in front of the film plane and measures the area that is out-

lined in the finder by the focusing rectangle. Because the CdS cell measures the light behind the pellicule mirror, it takes into account the 33 per cent loss of light used for viewing. It is obvions that the f/stop numbers of the lens do not represent the actual value of light intensity falling onto the film and used for making the exposure, which is no cause for concern, since, as I pointed out before, the meter takes care of the differential. This loss of light does not alter the depth-of-field relationships belonging to the marked f/stops.

When exposure is made by the self-timer, there is no one behind the camera to cover the eyepiece. Light would enter the camera through the eyepiece and would pass through the pellicule mirror, which would fog the film when the focal-plane shutter was open. The camera is, therefore, equipped with an eyepiece shutter, which closes the eyepiece when the index mark of the eyepiece-shutter ring, which surrounds the rewind crank, is aligned with the black rectangle. This feature of the camera indicates that care has to be taken to avoid penetration of stray light into the finder. Eyeglass wearers should be especially aware of this. Therefore I recommend that instead of taking pictures with eyeglasses, an eyesight-adjustment lens of appropriate strength be attached to the eyepiece. A rubber cup on the eyepiece is also a valuable help in avoiding light penetration in this area. It is necessary to avoid light penetration with any make and/or model of single-lens reflex camera with a through-the-lens metering system, because the CdS cells (usually two) are located at the right and left of the eyepiece, measuring the light falling onto the groundglass of the viewing system. Penetrating stray light may falsify the findings of the CdS cells, resulting in underexposure.

Canon EX EE Camera

All the advanced characteristics of the Canon single-lens reflex system can be found in this camera, such as a through-the-lens metering system, QL (quick loading) system, lens interchangeability (though this is limited), and others. Let us first examine lens interchangeability, which is somewhat different from the system used with other Canon SLR cameras. Three lenses are available for this camera: the 35mm f/3.5 wide-angle lens, the 50mm f/1.8 normal lens, and the 95mm f/3.5 telephoto lens. Lens interchangeability, though limited, is nevertheless unique. To change to a different focal length only the front component of the lens has to be changed, while the rear component, which is common for all

Canon EX EE

the three focal-length lenses, along with the diaphragm, remains in the camera body. This solution has to be used in order to enable the electric-eye system to adjust the diaphragm automatically.

Now let us see how the metering system works. First we have to set the film speed on the shutter-speed dial by lifting up the outer ring and turning it until the desired film speed is in line with the index mark. There are, however, two index marks on the Canon EX EE camera. One, when the normal lens is used, whose maximum aperture is $f/1.8$, and the other, when the wide-angle or telephoto lens is used, at $f/3.5$, the largest aperture of both of these lenses. Set the film speed in line with the figure that is the largest aperture of the lens presently in the camera, $f/1.8$ with the 50mm lens and $f/3.5$ with the other two lenses.

The measuring system of the camera uses the shutter-speed priority method. First adjust the shutter speed by turning the shutter-speed dial to the desired speed number. After the desired shutter speed is set, turn the aperture-control ring, which surrounds the film-rewind crank, to the EE mark. When the EE is in line with

the mark, the CdS photocell is permanently switched on, and the metering system permanently keeps tab on the correct exposure by selecting the correct f/stop instantly and continuously wherever the camera is pointed. Since the selection of the light meter is transmitted to the closing mechanism of the diaphragm, the diaphragm closes automatically to that preselected f/stop number at the same instant as the shutter-release button is depressed. Actually, the shutter-release button activates the diaphragm-closing mechanism. You can actually see in the viewfinder the actual f/stop number that is selected by the light meter, which enables you constantly to see whether the f/stop is in the proper exposure range. If the indicator is pointing toward the overexposure warning mark or toward the underexposure warning mark, the shutter-speed dial has to be readjusted. In case you do not want to make use of the automatic exposure control, you have to rotate the aperture-control ring around the film-rewind crank until the indicator in the viewfinder points to that f/stop number you want to use. The CdS photocell measures the light of the total picture area, giving an average reading, but laying somewhat more emphasis upon the central section of the picture area.

When changing the lens, make sure that the infinity mark of the distance scale for the standard lens, which is on that part of the lens mount that remains in the camera body, is set at the orange-line indicator; this is the focusing ring of the normal lens. To focus the lens simply rotate the focusing ring until you see the image correctly focused in the viewfinder. But when another focal-length lens is attached to the camera (to the rear element of the lens system) its own distance scale has to be adjusted properly.

To do this, rotate the distance scale of the front component of the particular lens until the infinity mark of the distance scale lines up with the white index of the focusing ring, while the infinity mark of the original focusing ring, which remains in the camera, is in line with the orange index.

After the focusing mechanism has been correctly adjusted, you can focus the lens by turning the focusing ring. You can read the distances on the front component with the white index.

While focusing the lens, make sure not to turn the adjusted distance scale on the front component of the lens.

All the other features of the Canon EX EE camera are identical with the other Canon SLR cameras, except opening the back. To do this with the other Canon SLR cameras, you have to rotate the opening key at the bottom of the camera body. The Canon EX EE simplifies this procedure, since the camera back pops open when

the film-rewind crank is pulled out completely. When the film is properly loaded into the camera, just press the camera back and it snaps closed.

The Canonet QL 17

The Canonet QL 17 is the modernized version of the old Canonet cameras. At the first glance you will notice that the old selenium photocell that surrounded the lens is replaced by a CdS electric-eye system. This is but one innovation among many I will discuss further on. First let us examine the basic features of the camera.

The camera is a noninterchangeable lens type rangefinder camera. The maximum aperture of the lens is $f/1.7$. It is a six element

Canon New Canonet QL 17 with Canonlite D.

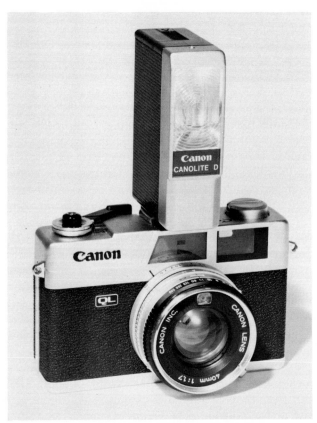

lens in four components with four rare earth element members. The shutter is of the conventional leaf-type and it is located between the lens components. The shutter speed can be set from ¼ sec. to 1/500 sec. and B. The rangefinder is a coincidence type and is located in the center of the viewfinder. The bright frame of the viewfinder moves automatically while focusing the lens to provide automatic parallax compensation. The aperture scale and the over- and underexposure warning marks are visible in the viewfinder. The exposure-control system of the Canonet QL 17 is similar to the Canon EX EE SLR camera. First the film speed has to be set, and then the required shutter speed (shutter-speed priority method). When the control ring is on the A (automatic) position and the shutter release button is depressed, the electric eye automatically readjusts the aperture, which actually closes down to the preadjusted mark. The actual f/stop used is visible in the viewfinder. When the pointer is on one of the red marks, this indicates that either there is not enough light (if the pointer is on the upper red mark near $f/1.7$) or that there is too much light, (the pointer is on the lower red mark near $f/16$), so the picture would be overexposed. In both cases the shutter speed has to be readjusted (increased or decreased) to bring the exposure into the correct range. When the aperture ring is turned from the A position the electric eye is disconnected and you can set the aperture to any desired f/stop manually. In this case the pointer in the viewfinder is on the upper red mark, near $f/1.7$.

A unique feature of the Canonet QL 17 is the completely automatic aperture control when using either the Canolite D Speedlite unit or any other type of flash or speedlight unit of known guide numbers. When you slide the Canolite D into the accessory shoe of the camera, and the aperture ring is set to A, a miraculous thing happens. While the lens is focused, the focusing mechanism, which is coupled mechanically to the diaphragm-setting mechanism, automatically sets the diaphragm to the correct f/stop that is required by the flash to subject distance in accordance with the guide number of the flash unit and the film. Thus, there is no need to calculate the correct f/stop in the usual way (dividing the guide number by the subject distance). The only thing you have to watch is that the pointer in the viewfinder is within the two red marks. If it points to one or the other of them, it indicates that you are either too close (too much light) or too far (insufficient illumination) to or from the subject. You can set the f/stop automatically while focusing with flash or strobe units other than the Canolite

D, as well. Just move the aperture ring from position A to one of the corresponding blue numbers to the right of the A (28, 20, or 14), and plug the synchro cable of the flash or strobe unit into the flash socket of the camera. The socket is at the upper left side of the camera and is easily accessible by depressing the cover in the direction of the arrow. Because the blue guide numbers are calculated in meters, the corresponding guide numbers calculated in feet are the following: 42 for the No. 14, 60 for the No. 20, and 84 for the No. 28. When using flash bulbs, set the shutter-speed dial to 1/30 sec., and when using electronic flash units, you can use any shutter speed. These guide numbers are valid for 100 ASA films. If you are using a different kind of film, you have to return to the old method of guide-number calculations and you have to set the lens diaphragm manually. As you can see, this camera is designed to eliminate most of the problems of exposure calculation in daylight, incandescent light or when using flash.

The Canonflex

The Canonflex was the first camera introduced in the single-lens reflex line of Canon; its basic operational functions are the same as those of any other single-lens reflex camera, though the Canon Pellix is an exception. The differences between the standard Canonflex and contemporary single-lens reflex cameras are: film advance is achieved by a trigger mounted on the baseplate of the camera; with the exception of the Canonflex RM, there is no built-in exposure meter, though a meter can be coupled directly to the camera by sliding it onto the shutter-speed dial. By setting the shutter-speed dial of the meter to any desired shutter speed, the shutter of the camera is automatically set to that particular speed. The pointer of the meter indicates the correct f/stop; by moving the preset aperture ring of the lens to that f/stop, and by depressing the shutter-release button, the diaphragm automatically stops down to that preset f/stop. The trigger on the baseplate not only advances the film, cocks the shutter, and advances the framecounter-dial, but it also cocks the spring of the diaphragm-closing and reopening mechanism as well.

Since the lens mounts of all the Canon SLR cameras are identical, the Canonflex lenses can be used on any other Canon SLR camera and vice-versa. However, because the diaphragm-actuating mechanism differs in some models, the Canon FL series lenses in

the Canonflex and the Canon R series lenses (designed for the Canonflex) can be used manually only, on the newer types in the Canon SLR family. That means that after focusing with a fully opened diaphragm, the lens has to be closed down manually to the preselected f/stop before the shutter is released.

The Canonflex R2000

1. Super-Canomatic Lens R 50mm f/1.8
2. Knurled focusing ring
3. Lens distance scale
4. Lens depth-of-field scale
5. Finder lock lever
6. Film type reminder
7. Direct flash connector socket
8. Film speed reminders (DIN and ASA)
9. Film rewind crank
10. Eye-level pentaprism finder housing
11. Exposure counter dial
12. Shutter release button (cable release socket)
13. Time lever
14. Single-pivot shutter speed dial
15. Meter mounting shoe
16. Built-in self-timer
17. Lens visual aperture ring
18. Lens preset aperture ring

Back of Canonflex R2000
1. Eye-level pentaprism finder
2. Direct flash connector socket
3. Back cover opening key
4. Trigger-action winding lever
5. Film rewind release button
6. Tripod socket
7. Hinged back

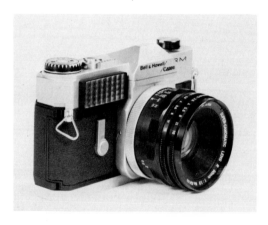

The Bell & Howell Canon-flex RM.

Canon 7 and 7S

The most obvious feature of these new cameras is their $f/0.95$ lens, an enormous piece of glass fast enough to capture moving objects in light so dim an ordinary camera couldn't stop the action with the fastest film.

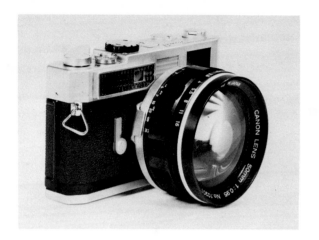

The Bell & Howell
Canon 7

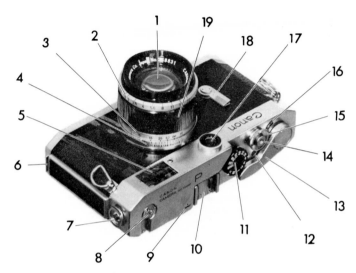

The Canon Populaire
1. Canon lens 50mm $f/1.8$
2. Lens aperture scale
3. Lens distance scale
4. Lens depth-of-field scale
5. Range- viewfinder window
6. Lock for hinged back
7. Flash unit connector socket
8. Film rewind crank
9. Film plane mark
10. Accessory shoe
11. Single pivot shutter speed dial
12. Film transport indicator
13. One stroke film winding lever
14. Shutter release button
15. Film rewind ring
16. Exposure counting dial
17. Rangefinder window
18. Self-timer
19. Knurled focusing ring

67

What does this super-speed lens mean to you as a picture taker? On pages 94-97 I discuss the factors to be taken into account when working with ultra-fast lenses. Obviously, most of the advantages and disadvantages of high-speed lenses apply to the $f/0.95$ lens, and are in fact multiplied. Depth of field, for example, is extremely shallow at huge lens openings. This shallow depth of field naturally limits the kind of pictures you would take at maximum aperture. For a nighttime landscape, you'd be more likely to use a moderate aperture and a long exposure than a wide-open lens and a short exposure. On the other hand, when you want to bring only limited subject matter into focus—a pair of eyes, a hand, a flower—you might open the lens wide and use the fastest corresponding shutter speed.

The lens extends the use of photography in the realm of "available darkness." You might find yourself in a situation where you are unable to use shutter speeds faster than ⅛ sec. at $f/1.4$. This speed is not great enough to capture action and leaves you vulner-

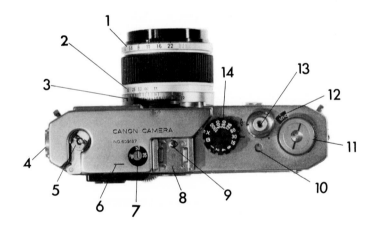

Top view of Canon VI

1. Lens aperture scale
2. Lens distance scale
3. Lens depth-of-field scale
4. Flash unit connector socket
5. Film rewind crank
6. Film plane mark
7. Viewfinder dial
8. Accessory clip
9. Automatic parallax adjustment pin
10. Film transport indicator
11. Film winding knob
12. Film frame counting dial
13. Shutter release button
14. Single pivot shutter speed dial

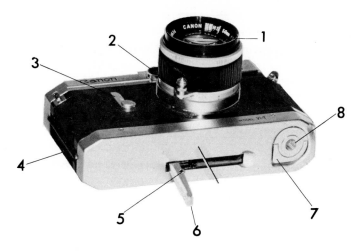

Bottom view of Canon VI

1. Canon lens
2. Rangefinder window
3. Self-timer
4. Hinged back
5. Trigger retracting button

6. Rapid wind trigger (retractable)
7. Magazine opening key
8. Tripod socket

able to camera shake. When you can open the lens to $f/0.95$, you can shoot at 1/30 sec., which will stop movement and make for a steadier picture.

Another advantage of such a fast lens is that it allows you to use a slower, finer-grained film in situations where you once had to use faster and grainier films. Naturally, this will give you sharper resolution and a greater possibility of enlarging your negatives into high quality prints.

A major difference between this model and its predecessors is the built-in exposure meter. To set the film speed, press the button in line with the words "Made in Japan" at the back of the camera. Then turn the shutter-speed dial until the proper film speed figure appears in the window (there are actually two windows, one for ASA and the other for DIN values). Then turn the small knurled wheel, to the needed sensitivity range position. To find the correct exposure quickly and easily, choose an appropriate aperture, then turn the shutter-speed dial to match a needle with the pre-set aperture number appearing in the light-meter indicator.

The frame selector of the multifocal viewfinder is on top of the camera between the film-rewind crank and the diaphragm scale of the exposure meter. It can be adapted at the turn of the selector for 35mm, 50mm, 85mm, 100mm, and 135mm lenses. A figure visible in the range-viewfinder always indicates the focal length of the lens in use. Automatic parallax compensation is provided by means of frames which shift as you focus.

The film-advance lever is on top of the camera, and it can be operated either by a single stroke or by two or more shorter strokes. The knurled ring around the shutter-release button can be set in three positions. When the dot on the wheel is in line with the letter A, you can take pictures; when it is in line with the red dot, the shutter-release button is locked; when it is in line with the letter R, you can rewind the film. When advancing the film, the red dot in the small window under the release button rotates, indicating that the film advance is operating properly.

All thread-mount lenses for other Canon models can be used on the Canon 7 and 7S, but the $f/0.95$ lens of this camera cannot be attached to any other Canon camera, since it has a bayonet mount which fits the outside bayonet mount of the Canon 7 and 7S only. To attach the lens, turn the lock at the rear of the lens mount counterclockwise (with the camera facing you) until it releases. Then attach the lens to the camera so that the red dots on the lens mount and on the camera mount align. Finally, turn the lock clockwise until it stops. To detach the lens, reverse this procedure.

To open the hinged back of the camera, first lift the half ring of the body lock key and turn it counterclockwise. This not only closes the Canon metal cartridge, but pulls the safety lock below the actual body lock lever. This lever is located at the left side of the camera close to the baseplate. When you pull the lever down with your fingernail, the camera back is released and the film counter mechanism is reset to the starting position (S). To close the camera, snap in the back and turn the lock key clockwise. At the same time you can see how the safety lock, below the opening lever, is put into the locked position.

To make the Canon 7 and 7S still more versatile, they can be used in conjunction with the new reflex housing MB-2, which accepts two new short barrel, bayonet mount lenses, 135mm $f/2.5$ and 250mm $f/3.5$. When the Bellows R is added to this combination, the cameras become ideal instruments for close-up photography.

All the other operations with the Canon 7 and 7S are identical with the other late model Canon rangefinder cameras (models V, VI, or P).

4

Handling and Operating Your Camera

Canons accept any standard 35mm cassette, as well as the Canon Film Magazine. You may buy film in factory loaded cassettes in 20- or 36-exposure rolls, or you may load your own empty cartridges if you buy bulk film.

To prepare the Canon for operation, perform the following steps:

1. Set the film-speed dial. To do this, lift up the ring surrounding the shutter-speed dial and rotate until the desired speed index appears in the window.

2. Open the camera. If you turn the opening key on the baseplate counterclockwise, the hinged back of the camera can then be opened.

3. Insert the film. When the back cover is opened the QL (quick loading) cover opens simultaneously readying the camera to accept the film. After raising the rewind knob all the way, the cartridge can be inserted into the receptacle. Then push the rewind knob back into the axis of the cartridge. You may have to turn the knob slightly to the left or right if it does not engage into the cartridge at once. Now pull the end of the film leader to the red mark and close the back cover half way. This action will close the QL cover completely. In this position you can check through the sprocket window to see whether the film perforations are correctly engaged onto the gear.

4. Set the first frame into position. While you loaded the Canon, a couple of frames were exposed to the light. These frames should now be cleared from the film gate by advancing the film three times. Since the lever can be operated only when the shutter is released, you have to depress the shutter-release button before each advance

71

of the film. Hence, the operation is turn-press-turn-press-turn. After the third turn the first frame is in position and the exposure-counter dial is advanced to 1. The dial was turned to the S (start) position automatically when you opened the camera back.

One complete wind of the lever advances the film, cocks the shutter, advances the exposure-counter dial, readies the spring-back mirror and cocks the aperture close-down and reopen mechanism of the lens system. The shutter-release button cannot be pressed unless the shutter is completely cocked.

Now your Canon is in operating condition, but before taking any picture you have to set the camera controls.

1. Setting shutter speeds.

The figures on the shutter-speed dial represent fractions of a second (except the figure 1, which indicates a full second). Hence, the shutter can be set for a speed of 1, $\frac{1}{2}$, $\frac{1}{4}$, $\frac{1}{8}$, 1/15, 1/30, 1/60, 1/125, 1/250, 1/500, 1/1000 sec., B, and X (for speedlight synchronization). To set the shutter speed, rotate the dial in either direction until the desired time figure clicks in line with the index mark on the time lever. If the dial is set to the X mark, the shutter permits an approximately 1/60 sec. overall exposure time, but the exposure on the film will be made by the light of the electronic flash (except in the case of fill-in). So the actual exposure time depends upon the flash duration of the speedlight unit used, which is much shorter than 1/60 sec. (1/600 and up, varying with make). The RF Canons are provided with a T mark which is used when you wish to leave the shutter open without continuous pressing of the shutter-release button. We can close the shutter again if we turn the speed dial off the T mark. B (bulb) and T (time) are used for exposures longer than one second.

2. Setting the f/stop.

The diaphragm of the Canon lens is wide open during viewing and focusing and also after the exposure is made, so that we can see the image in full brightness at all times. Moreover, the mirror snaps up and instantly springs back to the viewing position, so there is no image blackout at the moment of exposure.

To set the f/stop, turn the ring until the desired f/stop figure is in line with the index mark. The automatic aperture mechanism does the rest, and the picture will be taken at the f/stop that was preselected on the preset aperture ring.

The A-M ring, which is near the camera body, allows you to view the image through the lens stopped down when it is on the M position. After examining the image, you should return this ring to its original wide-open position before releasing the shutter.

72

3. Focusing.

Focusing is done through the lens by rotating the knurled focusing ring of the lens barrel. The field of view that appears in the viewfinder is identical to what will be photographed on the film. This is true regardless of which lens is used, so the viewer is absolutely free of any kind of parallax. It is easy to notice on the center spot, which consists of tiny microprisms, when the object is not in correct focus.

The distance scale is on the rotating part of the lens barrel, both in meters and in feet. When a distance figure is in line with the index mark on the fixed part of the lens barrel, then the lens is focused to that distance, unless infrared film is used. When infrared film is loaded in the Canon, focus the lens as usual, read off the distance of the object focused from the distance scale, and set this distance figure opposite the R mark. So if your object is in focus at infinity, set the infinity mark opposite the R mark instead of the regular index mark. You will then have the focus for infrared photography.

Depth of field scale

The distance-index mark is right in the middle of other marks, which represent f/stop values on the depth of field scale. The figures are identical on either side of the mark. When the lens is focused at a given distance, everything will be sharp between those two distances in line with the two identical f/stop figures which represent the f/stop used. You may see the actual depth of field if you rotate the A-M ring to the f/stop chosen. But after doing this, do not forget to turn it back to its original wide open position.

Double exposure

You can take any number of exposures on the same frame in the following manner: After an exposure is made, depress the film rewind button, actuate the film-advance lever, and take another exposure. Winding the trigger-action lever after depressing the rewind button will not advance the film but all its other functions will be completed (cocking the shutter, readying the instant return mirror, and cocking the aperture mechanism).

Built-in self-timer

1. Turn the self-timer key counterclockwise until it stops. This can be done either before or after cocking the shutter.

2. Press the shutter release button. The timing device starts working immediately, and you can hear it (it is a continuous buzz).

3. Take your predetermined place in front of the camera at the prefocused distance. You have ten seconds in which to do this. In about ten seconds the self-timer mechanism actuates the shutter and the exposure is made.

Once the self-timer is cocked, it cannot be released unless the shutter release button is actuated. To prevent camera jar it is advisable to use a cable release, and the camera has to be placed on a sturdy tripod.

Rewinding and unloading

1. Place the lens cap on the front of the lens.

2. Depress the rewind release button on the baseplate of the Canon.

3. Raise the arm of the rewind crank.

4. Rewind the film by turning the crank clockwise.

5. Count the windings (a 36-exposure roll requires about 30, a 20-exposure roll requires about 20 turns). I will explain why later. Close to the end of the 20 or 30 turns, take care and stop rewinding when you feel no more resistance and you hear the film slip out of the take-up spool.

6. Open the back cover by turning the camera opening key counterclockwise.

7. Pull out the rewind crank. This will enable you to take the cassette from the receptacle room.

Note: You do not have to press the rewind release button continuously, because once it is pushed down it remains in that position. This button will automatically return to its normal position when the film-advance lever is activated.

The film may be rewound whether the shutter is cocked or not.

How to change the lens

To change the lens, hold the lens to be attached to the Canon SLR in one hand (rear lens cap already removed) and detach the other lens from the camera by turning the bayonet tightening ring counterclockwise with your thumb and middle or ring finger. Meanwhile, use one finger of your other hand to prevent the lens from falling out of your hand when the bayonet suddenly releases the lens mount. Then, attach the new lens to the camera so that the red dots on the lens barrel and the tightening ring coincide. Again, use one finger of your other hand (which now holds the lens you have

detached from the Canon) to insert the lens into its correct position. Then rotate the tightening ring clockwise with your thumb and middle or ring finger (whether the middle or ring finger should be used depends on the diameter of the lens barrel in relation to the size of your hand).

Important: Before attaching another lens to the Canon be sure that the CdS activating lever (and the lock lever, also) is in the "off" position.

The built-in exposure meter of the Canon single-lens reflex cameras

This is a system for measuring the intensity of light passing through the lens, of the spot-reading type. More particularly, it measures the intensity of light falling onto that area of the viewfinder that is enclosed by the rectangle surrounding the microprism spot used for focusing.

To use the meter, first set the appropriate film-speed index by lifting and turning the outer rim of the shutter-speed dial until the desired film-speed index number appears in the small window. Since the exposure is determined by two controls, the shutter speed and the f/stop, if one of them is fixed, the other has to be changed when light conditions change. When determining the correct exposure, therefore, either set the shutter speed permanently (shutter-speed priority method), and turn the f/stop ring to achieve correct exposure, or set the f/stop permanently and rotate the shutter-speed dial to achieve the same condition (the f/stop priority method).

Determine correct exposure of that area enclosed by the rectangle in the viewfinder by lining up the pointer of the exposure meter, visible in the viewfinder with the small circle. Since the spot reading measures only a small part of the entire picture area, point the measuring rectangle area to other parts of the picture area as well. If, for instance, you want a good average reading, you should point the rectangle toward the lightest and darkest areas of the field. If shutter-speed priority method is used, read both f/stop numbers and use an average. When the f/stop priority method is used, leave the aperture ring of the lens alone and rotate the shutter-speed dial while watching the movements of the exposure-meter pointer in the finder. When it is in line with the small circle, read the resulting shutter speed on the shutter-speed dial. It is a good idea to read different parts of the entire picture area and use the shutter speed that is between the two extremes. The spot-metering system gives you the advantage of pointing out cer-

tain areas of the picture and suppressing others. For instance, if you photograph a person in light clothing with dark background, and want details in both the background and the clothing, take an average reading. But if you want to suppress the details of the surroundings, then take the reading of the person only and use this reading for your exposure. In such a way, the clothing of the person will be correctly exposed, and the dark surroundings will be completely underexposed. The spot-reading method is a great help in backlit situations. It is a great help when using wide-angle lenses also to take readings of different spots of the widely covered area, and use either the average of these readings or a reading taken from the most important area. When using long-focus lenses there's less of a problem because the long-focus lens is used mainly to point out subject matter. The most important areas of the picture can be easily recognized and determined when pointing the measuring rectangle.

Shooting technique

Hold the Canon firmly, but gently. Do not press the camera jerkily against your face. Find a support for your elbows or lean against something. During the exposure, hold your breath, but only at the moment of exposure, and not too long before. The exposure is made with the right index finger in horizontal and in some vertical picture-taking situations. Another method for vertical situations is to depress the button with the right thumb. In this case both elbows can be supported. This method is useful in hand-held shooting with exposure times slower than 1/100 sec. and particularly with exposures slower than 1/30 sec. Either your index finger or thumb is used to depress the shutter-release button with a smooth, steady motion. Before and after the exposure, the finger used should rest on the shutter-release button. After an exposure is made, advance the film immediately; you should be ready for the next exposure as soon as possible.

I presume that you have read carefully the above instructions for the use of the Canon. Now, I will elaborate upon the little things I experienced when I first used the Canon and other cameras.

I shall start *in medias res* and I shall suppose that you are close to the end of a roll. Please watch the exposure counter carefully and keep in mind how many frames you have left. Otherwise, in the heat of work when you are energetically pulling the trigger, you may tear the film end from the take-up spool of the cassette, especially if the film end is not fastened to the spool by tape. If such an

accident occurs, you have to take the film out in a dark room or changing bag. On one occasion, although the film was fastened to the spool by strong adhesive tape, I felt a strong resistance when I tried to advance the film. I also could not rewind the film. The film end had slipped out of the mouth of the cassette, but the tape was still attached to both the film end and the take-up spool. When I tried to rewind the film, the film end did not find its way back into the narrow slit of the cassette. Hence, on the 30th exposure, be careful. This advice applies with any 35mm camera.

If everything goes right after the 36th exposure, push the rewind release button. By turning the rewind crank the film will be pulled back into the light-tight cassette. You may also make errors during this simple procedure. Namely, you may feel resistance even though the film has not been pulled back completely into the cassette, and you may open the camera back, thinking that the film is already safe. I do not have to point out that many valuable pictures could be destroyed. To avoid this and another mistake—of which I will speak presently—please count the turnings of the rewind crank. As I stated earlier, allow about 30 turns for a 36-exposure roll and about 20 for a 20-exposure roll.

The other mistake is rewinding the film completely into the cassette. You should not allow the film leader to disappear completely into the cassette. Instead, when you feel, and perhaps hear, the film coming loose from the take-up spool of the camera, stop rewinding. Why is this a mistake? First of all, light may penetrate through the mouth of the cassette (especially if you reload your own cartridges several times), when there is no film filling the slit. Second, when you develop the film, you have to cut down the film leader before loading the film into the tank. This is much easier to do in full light than in total darkness, which is necessary if the film has slipped all the way into the cassette.

By turning the opening key counterclockwise you may open the camera back. The instant you do this, the film-counter mechanism springs to the starting (S) position. If you use the Canon Film Magazine V, the opening key also closes the slit of the magazine, which is wide open during the actual picture taking to eliminate friction of the film against the tight slit of conventional cartridges. If foreign material sticks to this tight slit, an annoying scratch along the film will occur.

You can remove the cassette by pulling the rewind crank out completely. I tear or cut off the film leader immediately. This is a reminder to me that the film is exposed. To remind me what kind of film is in the cassette (which is important to determine the de-

veloping time) I mark this on the part of the film which remains after the leader is cut or torn off, when I load the cassette.

Now you can load a new roll of film into the Canon. I emphasize very strongly that both unloading and loading the camera have to be done in shadow, and the cassette should be put into the container as soon as possible. This rule is valid, of course, for new film also. If there is no better opportunity, one's own shadow can serve as a shade. Moreover, take care that loading and unloading of the camera take place in a dust-free place (beware of a nearby ashtray). It is definitely not recommended that you open the camera back outdoors on a windy day. In this case, you must find some kind of shelter.

I would like to draw your attention to a very important thing during the loading and unloading of the camera: Please, every time you open the camera back, blow or brush out the inevitable bits of dust or film splits from the camera body and from the back, even if you find the camera perfectly clean. In this way you may prevent scratches and spots on the film. Dust is the greatest enemy of 35mm photography, and this danger begins the moment you load the cartridges and remains throughout the whole photographic process.

Focusing

If you wear eyeglasses for reading, critical focusing may be difficult without glasses. Perhaps you do not even know that you need glasses, and the difficult focusing of the single-lens reflex camera may bring this need to light. Since persons who do not wear glasses all the time dislike putting them on for focusing and taking them off again to look at the subject, and so on, eyesight adjustment lenses are available to slide into the eyepiece of the camera. If the factory made diopter ($+1.5$, 0, -2.5, -4) does not match your eyesight, your optician can test to determine what diopter is required, and he can grind the glass to the proper shape and replace the old glass with the new one. The diopter of this glass is not necessarily the same as the prescription for your glasses. Moreover, you should decide in advance which of your eyes should be used for focusing the camera and have the strength of the glass matched to it.

Checking the depth of field by viewing through the lens is useful if you do not have to stop down the lens too much. Using a small diaphragm, the image is so dark that you can hardly see anything, including the depth of field. In such a case (and it is recommended in other cases also), you should use the engraved depth of field

scale for predetermining the depth of field. This method is much more exact than the quite subjective and uncertain viewing method.

After focusing is done, and after all those procedures and considerations essential to making the photograph (I will describe them in detail in Chapter 6) reach the final point, you can press the shutter-release button, but take care. The improper and careless execution of this simple operation can jeopardize all our efforts put into the creation of that picture, and can even jeopardize the efforts of the Canon Camera Company to put into your hands such a wonderful instrument as the Canon with its marvelous lenses. I call these lenses marvelous because of their inherent superior sharpness and brilliance of image.

Camera jar (also called camera movement, or camera shake) is that devil that may foul efforts to produce a photograph as sharp as the image rendered by the lens. This phenomenon is thoroughly discussed, examined, and explained in connection with the standard of sharpness in one of my previous books, *Improved 35mm Techniques*. Here I would like to explain only how to avoid, or at least minimize this danger.

I start from the basic point of view that the 35mm system makes for the greatest mobility when the camera is hand-held. Hence, in an overwhelming majority of cases we reject the use of a tripod. However, as you will learn later, the tripod does not necessarily overcome camera jar, and, in some cases, we can assure sharpness more easily without a tripod than with it.

Without going into further explanations, the degree of camera movement, noticeable on the final print, depends upon the shutter speed, the focal length of the lens, and on the degree of enlargement. I mentioned in Chapter 1 that the longer the focal length of the lens and the slower the shutter speed, the greater is the possibility of camera jar, which comes into existence at the instant the shutter is released. Therefore, how you hold the Canon and how you press the shutter-release button is of utmost importance. You do not have too much to worry about when the shutter speed is 1/250 sec. or faster when lenses up to 100mm are used. The worries begin when the shutter speed is slower than 1/250 sec., or the focal length of the lens is 135mm and up, or both. You can see the actual trembling of the image in the viewfinder when a long-focus lens is attached to the Canon. To overcome this trembling you should search for a steady support for the Canon. Steady support does not necessarily imply support of the camera body—though this is the best solution—but means a steady support of your own trembling body, arms or head, or at least a comfortable position that

will minimize this trembling. When you feel that you have found the best position, do not ruin everything by a sudden push on the shutter-release button, especially at slow shutter speeds (under 1/30 sec.) even when shorter focal-length lenses are used. Do it gradually, gently. After a while you will find out how to bend your finger for releasing the shutter without transferring this motion to the camera body itself.

How to hold the Canon properly was explained previously; however, I would like to pursue the subject further and relate some of my own findings.

If you release the button with your right index finger either in the horizontal or vertical picture taking position, you can focus the lens with your left hand and after the exposure is made you can advance the film using your right thumb. This is quite comfortable in horizontal picture taking situations. But in vertical situations, your right elbow is up in the air and this does not allow such security as when both elbows are at least resting against your chest. Therefore, when I could not find a steady support for my right, upward pointed elbow, or my left, camera-holding arm, and the exposure was longer than 1/250 sec. (up to a 100mm lens) or 1/500 sec. (up to 200mm), I reversed the camera and pressed the release button with my right thumb. Having both elbows down affords greater security against camera shake, and it is not too significant that it is a little awkward to advance the film—at least at first—since a secure exposure has been made. The security of the actual exposure is more important than any other consideration (such as being unable to take two insecure exposures within 1/10 sec. of each other).

Some situations may require the use of a tripod. Some people may achieve hand-held exposures of as much as $1/4$ sec. without jerking the camera. Others cannot manage this at a much faster speed, say 1/30 sec., even though they are leaning against a support. Hence, if you do not have a solid support for the camera itself, you must use a tripod.

Using a tripod with a long focus or extra long focus lens is not a cure-all. Even the sturdiest tripods tremble a little bit, and this is magnified by the increased focal length of the lens. To minimize this you have to prop up the camera-lens unit at two points. One is the regular tripod socket. The other is the lens barrel. For the latter job, a second tripod, a fence, wall, or similar steady object will do quite well. It is not a bad solution to place the entire camera-lens unit on a steady, solid object, rather than a trembling tripod. Of course, when you are using a tripod, you must also use a cable release.

5

Working with Canon Lenses

I assume that the reader is already the owner of a Canon camera, and knows from his own experience the perfect performance of the lenses manufactured by the Canon Camera Co. Knowing that a lens is excellent is satisfactory only for a snapshooter, whose goal is sharp photographs under any circumstances. If one's goal is higher, we have to know somewhat more about the lenses than their excellence and reliability. We have to know how to make use of the different features determined by their focal length and speed. In other words, we have to know how to make best use of the opportunities offered by lens interchangeability.

First of all, we have to get acquainted with the technical features of each individual lens. After we do, I will discuss the theoretical bases and the practical use and exploitation of lens interchangeability. I will do so without regard to which type of camera the lens is mounted on (RF or SLR), since the optical construction of most of the lenses available for Canon cameras is identical. Of course, if it is not (as in the case of wide-angle lenses), I will discuss them separately. However, the difference between optical or mechanical constructions does not influence the manner of the creative use of any lens.

In the following tables you will find all the technical data and necessary information about the lenses presently available for the Canon SLR cameras. There are certain markings engraved on the mounting ring of the front element of the lenses such as FL, FD, or R and these markings obviously bear some significance. Though any lens with any marking can be attached to any Canon SLR camera and be used successfully, the manner in which the through-the-lens metering system operates and couples to the diaphragm makes a difference.

Lenses with an FD marking provide full-aperture metering coupled to the automatic diaphragm when mounted to cameras featuring the FD mount (Canon F-1 and Canon FTb).

Lenses with an FL marking provide stopped-down metering coupled to the automatic diaphragm when mounted to any Canon SLR camera with a through-the-lens metering system.

Lenses with an R marking can be used on any Canon SLR camera for stopped-down metering, but the diaphragm has to be set manually after metering. However, R series lenses with a diaphragm pin under the barrel work automatically with the Canon SLR's, which do not feature a through-the-lens metering system. The word "Canomatic" engraved on the mounting ring of the front element also indicates the automatic feature of the lens.

TABLE OF INTERCHANGEABLE LENSES FL FOR CANON SLR CAMERAS

Lens	Angle of view	Magnifi- cation	Construction Ele- ments	Compo- nents	Minimum aperture	Closest Distance In feet	Filter size (mm)
FL19mm f/3.5 R	96°	0.38X	11	9	16	1.75	Ser. No. 9
FL28mm f/3.5	75°	0.56X	7	7	16	1.5	58
FL35mm f/2.5	64°	0.7X	7	5	16	1.5	58
FL35mm f/3.5	64°	0.7X	6	6	16	1.5	48
FLP38mm f/2.8	59°	0.76X	3	3	16	3	48
FL50mm f/3.5	46°	1X	4	3	22	9.2in	58
FL50mm f/1.8	46°	1X	6	4	16	2	48
FL50mm f/1.4	46°	1X	7	6	16	2	58
FL55mm f/1.2	43°	1.1X	7	5	16	2	58
FL85mm f/1.8	29°	1.7X	5	4	16	3.5	58
FL100mm f/3.5	24°	2X	5	4	22	3.5	48
FL135mm f/3.5	18°	2.7X	4	3	22	5	48
FL135mm f/2.5	18°	2.7X	6	4	16	5	58
FL200mm f/3.5	12°	4X	7	5	22	8	58
FL200mm f/4.5	12°	4X	5	4	22	8	48
FL 55-135mm f/3.5	43°-18°	1.1-2.7X	13	10	22	7	58
FL100-200mm f/5.6	24°-12°	2-4X	8	5	22	8	55
FL 85-300mm f/5	29°- 8°	1.7-6X	15	9	22	12	72
R300mm f/4	8°	6X	5	4	22	5	48
R400mm f/4.5	6°	8X	5	4	22	10.2	48
R600mm f/5.6	4°	12X	2	1	32	20	48
R800mm f/8	3°	16X	2	1	32	44.3	48
R1000mm f/11	2.4°	20X	2	1	32	69	48
FL-F300mm f/5.6	8°	6X	7	6	22	13	58
FL-F500mm f/5.6	5°	10X	6	5	22	33	95

Note: FLP 38mm f/2.8 is for use with Pellix QL.
For lenses longer than 300mm, there are no distance scales. The shortest focusing distance is listed in the chart for reference.

TABLE OF INTERCHANGEABLE LENSES FD FOR THE CANON F-1 AND OTHER CANON SLR CAMERAS

Lens	Angle of view	Magnification	Construction Elements	Components	Minimum Aperture	Closest Distance In feet	Filter (mm)
Fish Eye 7.5mm f/5.6	180°	0.15X	11	8	22	—	Built-in
FD 17mm f/4	104°	0.34X	11	9	22	0.9	72
FD 24mm f/2.8	83°	0.48X	9	8	16	1	55
FD 28mm f/3.5	75°	0.56X	7	7	16	1.5	55
FD 35mm f/3.5	64°	0.7X	6	6	16	1.5	55
TS 35mm f/2.8	79°/62.6°	0.7X	—	—	22	1	58
FD 35mm f/2	62°	0.7X	9	8	16	1	55
FL 50mm f/3.5	46°	1X	4	3	22	9.2	—
[1]FD 50mm f/1.8	46°	1X	6	4	16	2	55
[1]FD 50mm f/1.4	46°	1X	7	6	16	1.5	55
FD 55mm f/1.2	43°	1.1X	7	5	16	2	58
FD 55mm f/1.2 AL	43°	1.1X	8	6	16	2	58
FL 85mm f/1.8	29°	1.7X	5	4	16	3.5	—
FD 100mm f/2.8	24°	2X	5	5	22	3.5	55
FD 135mm f/3.5	18°	2.7X	4	3	22	5	55
FD 135mm f/2.5	18°	2.7X	6	5	22	5	58
FD 200mm f/4	12°	4X	6	5	22	8	55
FD 300mm f/5.6	8.3°	6X	6	5	22	13	58
FL 55-135mm f/3.5	43-18°	1.1-2.7X	13	10	22	7	58
FD 100-200mm f/5.6	24-12°	2-4X	8	5	22	8	55
FL 85-300mm f/5	29-8°	1.7-6X	15	9	22	12	72
[2]FL 400mm f/5.6	6.2°	8X	7	5	32	—	48
[2]FL 600mm f/5.6	4.1°	12X	5	4	32	—	48
[2]FL 800mm f/8	3.1°	16X	7	5	32	—	48
120mm f/11	2.1°	24X	6	4	64	—	48

[1] Equipped with a coupling pin for the Canon Auto Tuning System.
[2] Front component interchangeable type. Focusing adapter (1-component, 2-element, FL automatic diaphragm, with A-M ring). Filter is of insertion type with holder. Number of elements in chart are totals.

How to Make Use of Lens Interchangeability

Although the official classification puts the Canon-made lenses into six groups, such as wide-angle, normal, long-focus, telephoto, long telephoto, and extremely long telephoto lenses, in the examination of the effects and the use of lenses of various focal lengths, I will deal only with three classifications. They are the normal, the wide-angle, and the long focus group. The normal lens as a separate group is taken into account only as a necessary base for some kind of standard when comparisons occur.

I start with obvious explanations that do not need any further or advanced knowledge of photography.

Wide-angle lenses are used in the following situations:

1. When we do not have enough space to go farther from the subject in order to capture its entire dimension (or that part of the whole we need) in the frame. In such a case the wide-angle lens does what its name implies.

2. When we need great depth of field and cannot use a small f/stop. Or just for the sake of a tremendous depth of field (when everything, for instance, must be sharp between five feet and infinity and we would still like to maintain a short exposure time). Or when we use the zone focusing method to capture action as easily as we see it, since there is no need to focus when using this method.

Long-focus lenses are used in the following situations:

1. To bring distant subjects closer, when the photographer is unable to get close enough to the subjects with a normal lens on his camera.

2. To achieve a close-fitting (tighter) framing without getting involved in perspective distortion due to the close shooting distance which would be required when using shorter focal-length lenses for the same framing. Portraiture is a prime example of an effective use of long focal-length lenses.

The more advanced use of different focal-length lenses is connected with perspective control. Keep in mind that in photography it is possible to fool the perspective sense of the viewer. Therefore, the skilled and imaginative photographer can play with it at will. The following explanations and examinations are always made in the light of this possibility of manipulation, thus aiding you to recognize the opportunities offered by the wide range of different focal lengths.

Perspective

Perspective rendition is a presentation of objects lying one behind another in such a way that the distances between them are well-defined and recognizable. Our perspective sense is constant, because the focal length of our eyes is constant. Our perspective sense is also conditioned by the angle at which we view a scene. In photography, a third factor enters consideration, the viewing distance of the picture.

The correct viewing distance depends upon the focal length of the taking lens. This means that we see the same perspective as rendered by the taking lens when we look at the print from a distance equal to the product of the multiplication of the focal length

The wide-angle lens extends the visible distance between objects lying each behind the other.

The telephoto lens compresses the distances.

Diffraction at the edges of the diaphragm blades close to the smallest f/stop causes the star-like appearance of reflections of the sun on the water (opposite page).

The 35mm lens assured proper framing under the circumstances. There was no room to move further from the subject (below).

and the degree of enlargement. Although this distance is correct, it is not necessarily convenient. So, when we look at the print from its convenient viewing distance we need not know anything about the focal length of the taking lens, and we need not know whether we see the same perspective as that which the taking lens caught.

The 200mm lens assured proper framing under the circumstances. There was no possibility to move closer to the subjects.

Our perspective sense has been fooled. And even if we *did* know the focal length of the taking lens, we would prefer the convenient viewing distance to the proper one. The convenient viewing distance and the proper viewing distance coincide approximately when the picture is taken with the normal lens of a 35mm camera (45–58mm focal length).

On the other hand, the angle of view of the human eye (when we look at a scene without squinting) compares approximately with a 100mm focal length lens of a 35mm camera. So, in this relationship, the rendition of the normal lens is not correct; it is actually a wide-angle lens. From this bilateral performance of those optical instruments placed in front of a camera and called lenses, we can realize that we actually never see the same image on a print that we saw in nature. Our illusion, then, may be changed by changing photographic means in relationship to the two previously mentioned fixed standards of human vision. This is the theoretical basis for the skilled use of lens interchangeability. Now, let us see how it works in practice.

As I stated before, perspective rendition depends upon the recognizable distances of objects lying one behind the other. But among the circumstances of photography this recognition depends upon the relationship of distances between the camera, foreground, and background. Since a picture is always limited by its frame, what kind of objects fall within this frame depends upon the angle of view of the lens. On the other hand, if we wish to incorporate the same foreground objects with the same size into the picture by changing the focal length of the lens, we have to go closer (in the case of a shorter focal-length lens than the previous one) or farther away (in case of a longer focal-length lens) from those objects. But the distances between the foreground objects and other objects of the picture area, as well as their distance from the background, does not change at all, so the relationship of distances between camera and foreground and background is changed only when we get closer or farther away. In the case of a wide-angle lens (when we get closer) this relationship is increased, and in the case of a long-focus lens (when the camera-foreground distance was increased) this relationship is decreased. From a photographic viewpoint it is most important that when the relationship is increased, the perspective becomes extended, and when the relationship is decreased, the perspective becomes compressed.

This change of perspective rendition becomes more apparent when we look at the photograph from the vantage point required by the size of the photograph which is related—as I stated before

—to the required viewing distance of the focal length of the normal lens. Therefore, details of distant objects become more recognizable than in nature if a long-focus lens is used and in such a way an approaching effect is created. If a wide-angle lens were used, foreground objects would be pointed out more definitely, suppressing the pictorial value of other objects in the picture area. This, in combination with the inherent diminution effect, creates a feeling of distance and departure from the background and objects farther from the lens.

When we changed the focal length of the lens without changing the camera vantage point, the real perspective rendition did not change at all. Only our perspective illusion was changed, due to the imbalance between the convenient viewing distance and the proper viewing distance. But when we changed the camera position, too, in order to get a proper framing for the photograph, a quite different perspective rendition came into existence strengthened by the first.

But it is not only the straight change of perspective rendition that may influence our perspective sense, or, as I can name it, our illusion of depth. This illusion may be influenced by other photographic means (which are connected with the focal length of the lens) also. They are haze effect and the effect of regulated depth of field. Both effects originate from the psychological fact that objects which are easily recognizable and well defined seem closer than objects with hazy, less well defined, or unsharp details. This is why distant mountains appear closer when the air is clear.

Aerial haze

The effect of aerial haze may also cause unwanted results when long-focus lenses are used. These lenses select only a segment of the area, which we see in nature, but haze within that segment is incorporated within the frames of the picture in its full strength. The longer the focal length of the lens, the smaller the segment that will be reproduced, and the stronger will be the appearance of the aerial haze within the picture. If we use the long-focus lens to bring distant objects closer, this effect has to be taken into account. Otherwise, we lose contrast and the entire picture appears flat. We may overcome this phenomenon by using filters (mostly orange or red filters), but sometimes the aerial haze is so strong (or the focal length of the lens is so great) that no filter can help. In such cases infrared film has to be used in combination with an

90

infrared filter. Since photographic lenses are not corrected for infrared radiation, the letter R on the barrel of Canon lenses indicates that point which should coincide with the distance mark of the lens distance scale instead of the middle line of the depth-of-field scale after we have focused in the usual way.

Ultraviolet radiation

With the use of long-focus lenses another kind of invisible radiation has to be taken into account. This is ultraviolet radiation, which is on the other side of the spectrum from infrared radiation. Photographic lenses are not corrected for this radiation either. Although it is invisible to the eye, it is nevertheless recorded by the film in the form of unsharpness. So, when we take pictures at high altitudes (over 8,000 feet) or on the beach in clear weather (dust and vapor filters ultraviolet penetration) we have to use a UV filter to avoid unsharpness. We also have to use this filter when a normal or wide-angle lens is in the camera, since this phenomenon is not limited to the use of long-focus lenses. However, it is more conspicuous in distant shots and, therefore, is more dangerous with the use of long-focus lenses.

The effect of warm air may cause unsharpness also. The apparent trembling of the contours of distant objects grows more obvious in the picture as the focal length of the lens increases, if we failed to use a fast enough shutter speed. But even if we do use a sufficiently fast shutter speed we cannot overcome the phenomenon of a straight line showing as a zigzag in a picture because its trembling was "frozen" by a fast shutter speed. This phenomenon occurs on warm days when the sun heats the planes (for instance, rocks or pavement) and these planes heat the air above by reflection. Since warm air is struggling upwards and cold air downwards, this continuous motion and mixing of cool and warm air causes the apparent trembling of objects behind the area of moving air because the refraction index of warm air is different from that of cool air. This danger always has to be taken into account when using long-focus lenses.

Framing

As I stated before, the perspective rendition actually does not change at all when we take a photograph from the same camera vantage point with another focal length lens. Now, one might ask

why should we change the lens when we may change perspective rendition by changing the position of the camera, in combination with cropping during enlarging or, when, simply by cropping, we can assure correct framing at will whether we wish to change perspective or not. Although it is true that by means of cropping we may achieve an effect similar to the one we got by using a particular lens for the required angle of view, by doing this we violate one of the basic standards of 35mm photography, which is related to the accepted tolerance of sharpness.

This standard relies upon the limited resolving capability of the human eye. It is determined by taking into account the convenient viewing distance. This means that when we look at a print from its convenient viewing distance, we cannot separate lines closer to each other than 1/50mm multiplied by the degree of enlargement. The resolving power of Canon lenses is much superior to this standard, so we have a certain reserve in this relationship, and slight cropping does not make too much difference in sharpness. But when we look at an $8'' \times 10''$ print from its convenient viewing distance, which is about 15–17 inches, and this print was made from a tiny part of the negative to achieve the framing of a longer focal-length lens, the result cannot match the accepted standard of sharpness (which is, in the case of an $8'' \times 10''$ print, about 1/6mm). This standard can be maintained only when most of the negative surface is projected onto the photographic paper, and it was computed so.

This is the reason for changing the focal length of the lens (actually, in such cases the different angle of view of lenses of different focal length is necessary) when different framing is necessary. Since perspective rendition, camera vantage point, and framing work together for achieving pleasant results in the composition of a picture, the great variety of lenses of different focal lengths available for Canons makes it easy to reach this goal. But please do not think you can attain your goal only by buying all the available lenses for your camera, by investing a couple of thousand dollars in lenses. There are also less expensive means, thanks to the excellent performance of Canon lenses. Thus you can crop an image of a 135mm lens to the field of a 200mm lens or you can get the framing of an 85mm lens cropped from a negative taken by the 50mm

Slight cropping when enlarging can determine the proper composition of a picture.

lens. This is the slight cropping I mentioned before, when I stated that Canon lenses are superior in performance to the accepted standard of sharpness.

How to Handle Ultra-Fast Lenses

Not so long ago 35mm cameras were equipped with a 1:3.5 lens, and lenses under this aperture were accepted as fast and ultra fast, serving special purposes. In the wide-angle group there was no lens faster than 1:3.5 or 1:2.8, and the greatest aperture of the 135mm lenses was 1:4. And those fast lenses were so expensive that it didn't pay for an average amateur photographer to spend a lot of money for a one f/stop difference. Moreover, this one f/stop difference could not be used efficiently, since at that time films were so slow that one f/stop difference made possible an exposure time in available (dim) light conditions of perhaps $\frac{1}{4}$ sec. instead of $\frac{1}{2}$ sec. It was not significant. Besides, when those lenses were used wide open, sharpness was disputable.

After the introduction of rare earth element glasses in lens construction—the Canon Camera Co. was the very first manufacturer to do this—it was possible to manufacture fast and ultra-fast lenses of corner to corner sharpness and an actual sharpness even at full aperture as was unbelievable before.

Once, an editor of one of the camera magazines showed me a series of 8″ × 10″ test shots. The pictures were made at a ballet performance, and after close examination of shadow details, sharpness, grain, and stopping of subject movement, I guessed that the pictures were taken on a new kind of superfast film, with minimum graininess and maximum acutance, and were made with a 2¼″ × 2¼″ camera. I estimated an exposure of 1/500 sec. at f/4, guessing a film speed of close to 800 ASA. To my great surprise, the editor declared that my estimation was correct only in two respects. The shutter speed was 1/500 sec. and the focal length of the lens was close to the standard focal length used on 2¼″ × 2¼″ cameras. But the camera was a 35mm, the film was a fine-grain, high-acutance, medium-speed film (exposed and developed for 160 ASA), and in consequence of the relatively slow film the lens had to be used at full aperture, which was f/2. The lens was the 100mm 1:2 Canon, newly introduced at that time.

I tell this story not merely to laud the 100mm 1:2 Canon lens, but as an example of how to make use of the possibility offered by the perfect sharpness at their largest aperture of those superfast lenses. And since the standard lenses of present-day Canons feature

a maximum aperture under 1:2, and wide-angle lenses are going down to 1:1.5, and maintaining unbelievable sharpness at these apertures, we have to learn what has to be taken into account to make best use of these giant apertures, and what possibilities they offer.

I start with an obvious limit, which always has to be kept in mind, when using a large aperture; namely, the shallow depth of field. At close distances you cannot rely upon the security of the sharp zone, but you have to focus very exactly, and you can get sharpness only in and very close to the focused plane. For instance, when the 100mm Canon lens is focused to five feet the depth of field at $f/2$ is less than one inch. So, when, after focusing, you lean forward or backward unconsciously only a little bit, don't blame the lens because the eyes of the photographed person are out of focus (always focus on the eyes of a person or of an animal), but try to find something to lean against. The danger that important parts of the picture area have been thrown out of focus decreases, according to the optical laws of depth of field, when the distance focused upon increases.

When those previously mentioned ballet pictures were taken from a distance of more than 50 feet, the photographer could rely upon a zone of sharpness of more than 10 feet, so he could use a fast shutter speed with a medium-fast film. This is the main advantage of using fine lenses at such large apertures: the excellent sharpness of the lens at full aperture permits the use in dim light conditions of a slower film, which is necessarily superior in grain and acutance quality than a faster film.

The efficiency of large lens apertures increases as the focal length of the lens decreases, since the shorter the focal length of the lens, less concern for depth of field is necessary. On the other hand, limited depth of field may be used for pointing out subject matter even in good light conditions in combination with a low-speed film, without sacrificing any sharpness in those areas where maximum sharpness is a must. More obvious separation of subject matter from its background results from the fact that a larger lens aperture produces a more confused appearance of the out-of-focus areas.

The reliability of that one f/stop difference sometimes makes possible an unblurred recording of action with fast films when minimum light conditions are present. Slow shutter speeds, especially, are very critical in this kind of situation and it makes a big difference whether you can expose at 1/15 sec. or only at 1/8 sec.

A 14 × 17mm field was cropped from the negative. Due to the tremendous resolving capacity of the 100mm Super Canonmatic-R lens, even at $f/2.8$, the 8″ × 10″ print is needle-sharp.

In conclusion, I can state that improvement of fast lenses broadened the horizons of picture taking. Prior to their development we were inclined to neglect these horizons, or if we had to take photographs, we were generally quite disappointed with the results.

The general application of fast lenses with SLR photography eased the difficulties of critical focusing, especially through the unsurpassed features of the Canon system.

Close-Up Work

Although the rangefinder camera, in combination with the mirror-reflex housing, can be used equally well as the SLR, the SLR system became generally known as the device for close-up, macro- and micro-photography. The closest focusing distances of the Canon lenses alone may be used for unusual close-up effects and for copy work, but when extended by the Bellows R or FL units, almost unlimited possibilities are generated.

Although you will find various tables in connection with close-up work in the last chapter of this book, I still find it necessary to explain some basic features and requirements of this work.

First of all, you have to know that you may achieve a 1:1 rendition if the subject in front of the lens is at a distance double the focal length of the lens. In this case, the lens-focal plane distance is much longer than at regular focusing distances. Therefore, the intensity of the exposure is different from a regular exposure, due to the law of illumination which says that the intensity of illumination is inversely proportionate to the square of the distance between the light source and the illuminated surface. Since the lens serves as the light source for the film, the basic exposure time has to be increased four times, because in a 1:1 rendition, the focal plane-lens distance has been doubled. But we do not always have such an easy way to calculate the new exposure time. The tables in the last chapter indicate the exposure factors for various magnifications or reductions, but we can calculate it easily if we know the degree of magnification or reduction. The formula is: exposure factor $= (1+m)^2$. In this formula the m signifies the magnification, which in the case of a reduction is smaller than 1. For instance, when the image on the film is half the size of the object, the formula looks like this:

$$\text{Exposure factor} = (1+0.5)^2 = 2.25$$

So we have to open the diaphragm somewhat more than one full f/stop, instead of using the exposure-meter reading directly or

2¼ × longer exposure. You may find out the approximate size of magnification (or reduction) if you compare the known size of the object with the size of the area in the known negative size. For instance, when you take a photograph of an object two inches wide which fills almost the entire width of the film (which is 24mm), you know that in this case the magnification is about 0.5. This applies only for RF cameras since the behind-the-lens metering system of the SLR takes care of this matter.

As depth of field is very shallow in close-up work, you have to stop down the lens as much as possible. For instance, in a 1:1 rendition the depth of field of a 50mm lens at $f/16$ is 2.2mm, but at $f/1.8$ only 0.2mm. The depth of field increases, of course, when the magnification decreases, but it still remains quite shallow. For instance, when the reduction ratio is 1:5 (this means that an object about 5″ × 7″ fills the entire frame), the depth of field of a 50mm lens at $f/16$ is still only about 35mm.

If you take a photograph of a flat object, such as a plain reproduction, do not stop down the lens to its smallest $f/$stop. It is well known that the actual sharpness of a lens increases when it is stopped down from its maximum aperture to the medium $f/$stops (between $f/5.6$ and $f/11$), and afterwards it decreases again slightly. This rule is also valid in regular picture-taking situations if maximum sharpness is our objective, and the depth-of-field requirement is fulfilled with these medium $f/$stops.

Focusing is quite difficult in close-up work. Therefore, follow this procedure: Determine the approximate magnification and sharpness with the help of the extension of the bellows, and do the critical focusing by moving backwards and forwards with the entire camera. The waist-level viewer makes focusing easier in certain camera positions; such as when the camera is at a low level or when the lens is pointing downward.

Screw-mount lenses may be used for close-up work with Canon SLR's using the Lens Mount Converter A. Without the use of extension tubes, we can get closer to the object, since the SLR is deeper than the rangefinder Canons. Thus, the screw-mount lenses are initially farther from the focal plane than in their regular use. However, we are unable to focus screw-mount Canon lenses to infinity when they are attached to the SLR.

Since photographic lenses are constructed in such a way that they render maximum sharpness when the object distance is greater than the distance of the lens from the focal plane, for a 1:1 rendition the Canon macrophoto couplers are available in combination

with the lens mount converter and with the 50mm Canon lenses, which are reversed in use so that the rear element of the lens faces the object.

For copy work even illumination of the object being photographed is essential. At least two floodlights are needed for smaller objects and four for larger ones. We can find out how even the illumination is by placing an object exactly in the middle of the plane (in the axis of the lens). Comparison of the two or four shadows will indicate whether the illumination is even or not. Care has to be taken also to avoid glare. This is easily recognizable in the finder of the SLR and by a slight change of the position of the lights we can overcome this.

If you would like to take shadowless photographs of small objects, such as coins, jewelry, minerals, insects, etc., use the following procedure:

Place the object on a ground glass which is evenly illuminated from the bottom. This will give the illusion of a white background. The main illumination of the object comes from two diffusing screens (transparent paper) which are placed vertically into the set-up, and illuminated by floodlights from the outside. The camera is, of course, above the object, lens facing downwards. This kind of set-up is called a "tent" in commercial photography. If we have to take shadowless photographs of larger objects, perhaps we have to use a four-sided tent illuminated by four or more floodlights.

Microphotography is seldom done by amateur photographers, but, because the Canon SLR is very practical for this purpose, I can mention that a simple device, the Microphoto Hood, can be placed between the microscope and the Bellows R, which is attached to the camera body. For rangefinder Canons the Photo-Micrographic Unit, which incorporates a mirror-reflex housing for focusing, has to be used.

In the foregoing, I mentioned or explained the use of different accessories for the Canon RF and SLR. Now, for the sake of an easier survey, I would like to give a list of these useful accessories.

For close-up work

Close-up lens R 1: focusing range 13″-22″
Close-up lens R 2: focusing range 10″-13″
Both close-up lenses may be used for the 50mm, 100mm, and 135mm Super-Canon lenses. However, the focusing ranges given

Bellows M

above are related to the 50mm lens, and will be changed slightly if another lens is used.

Bellows R, FL, or M: This is a versatile accessory, and it can be used not only for close-up work, but as a focusing device of telephoto lenses over 200mm. It can be adjusted both vertically and horizontally by a lever that rotates 90 degrees. For use with telephoto lenses, it can be attached to the camera by the Tele-Coupler R.

Tele-Coupler R: This device permits using filters behind the rear element of the lens, by putting the filter into the slit of the Tele-Coupler R.

Waist-Level Viewer: Because of its 90-degree viewing axis in relation to the shooting axis, it permits convenient viewing during copy work when the Canon is attached to the *Canon Copy Stand R* in a vertical position. It may ease unobstrusive photographing also, since you do not have to hold the camera at eye level, and you can shoot at a 90-degree angle, or can hold the camera over your head and take photographs of a situation behind you.

Canonflex Macrophoto Coupler: This permits the 50mm *f*/1.8 and *f*/1.4 lenses to be reversed. Since the correction of regular photographic lenses is executed in such a way that it produces the sharpest image at extreme close-ups when the rear element of the lens is faced toward the object, this device can be used for 1:1 copy work to achieve the best possible rendition.

Camera Holder R4: This is used for easy and versatile copy work, since the holder has tripod bushings on two sides. The camera can be used in normal or in inverted positions.

Canon Photomicrographic Unit: This can be used with the Canon in combination with the appropriate *Lens Mount Converter A* and

100

Microphoto Hood. Then the unit couples to any standard microscope eyepiece with an outside diameter of from 24.7 to 25.2mm.

Lens Accessories

Filters

For lenses up to 200mm focal length, the filters screw into the front of the lens. Over 200mm they should be put into the filter ring of the Tele-Coupler R. In this way the filter is positioned behind the lens. Canon filters are made of solid optical glass, ground and polished optically flat on both surfaces. They are free from inside strain. They are available in the following colors: conversion A, conversion B, skylight, UV, light yellow, dark yellow, orange, red, and green.

Lens hood

It prevents the front element of the lens from being struck by light in back- or side-lighted situations, or from unnoticed reflections and other awkward light effects.

Lens mount converters

These are used when other mount lenses should be attached to the Canon SLR or when SLR lenses should be attached to the Canon rangefinder cameras.

The Converter A accepts screw mount Canon or Leica lenses or extension tubes. Focusing is possible only in the close-up range.

The Converter E accepts Exakta mount lenses and Praktica mount lenses.

The Converter B converts the bayonet mount Canon lenses to screw mount for use on Canon rangefinder cameras. However, when so adapted the SLR lenses will not couple to the rangefinder. Distances must be guessed or measured separately and set manually on the distance scale of the lens barrel.

Focusing adapters and lens head adapters

These are used when a Canon screw mount lens with detachable head should be used with the Canon SLR.

101

Any "RA" type focusing adapter in combination with the appropriate lens head adapter (8519, 1002 and 13535) can be used to convert a screw mount Canon 85mm $f/1.9$, or a 100mm $f/2$, or a 135mm $f/3.5$ lens for use with the Canon SLR.

The Focusing Adapter "RB"-10035 should be used when the Canon 100mm $f/3.5$ must be attached to the Canon SLR.

When using any type of adapter the lens head must be removed, of course, from its original lens barrel.

6

Procedures Before Releasing the Shutter

In the previous four chapters you learned the technical bases and theoretical explanations of the ideas and procedures which have to be taken into account before releasing the shutter. Releasing the shutter is the result of a complex mental activity, which determines the means for the proper selection of the important from the unimportant. Photography, therefore, is often called a selective art. One part of this selective activity is completely technical. The other part is completely aesthetic. The latter is called composition. Although the technical and aesthetic activities are most often combined with each other, I will separate them for the sake of better understanding and to pinpoint the ideas. I will deal with the technical aspects in this chapter and with the aesthetic aspects in the next one.

Proper Framing

When we are looking through the eyepiece of a Canon SLR camera or through the viewfinder of a Canon RF camera, our main objectives should be to place the subject in a favorable position within the picture area, and to maintain those rules which are required by the many means of photographic composition and performance. In order to get this proper framing we have, first of all, to determine the foreground, middleground, and background relationships together with the placement of the object or objects in these areas. This happens through two means.

1. By searching for a camera vantage point.

2. By determining the proper focal length of the lens from that vantage point.

The proper focal length lens (in this case 19mm) in connection with the camera vantage point determines the proper framing of a photograph.

This searching for a camera vantage point is done by moving back and forth and sideways, looking through the finder from time to time. This movement sometimes is very little—it may be only a few inches or less, to give a quite different appearance to the picture, or to eliminate some awkward object in the surroundings or background. When we have found the proper vantage point for the best reproduction of the subject, we have to judge whether the background-foreground relationship, together with the other compositional means, are in proper proportion. In most cases, with the present focal length lens in the camera (perhaps taking into account some cropping afterwards) we may find a pleasing rendition, since compositional means can be found with lenses of any focal length.

If the rendition with a lens of given focal length is not satisfactory, we may find an even better rendition with another focal length. In this way, we can correct the rendition or achieve a better one. Searching for the appropriate focal length is easy with the rangefinder Canons, since the luminous frames of the various focal lengths are always visible in the finder. With the SLR this is somewhat more difficult, since judgment can be made only when the actual lens is in the camera. To simplify things we may use a Universal finder which indicates in advance which focal length lens has to be attached to the camera.

The two factors mentioned above are theoretical separation only, and in practice the two cases work together in determining the proper framing and other requirements of a photograph.

After the requirements that are visible in the finder are fulfilled, we have to consider those requirements that are invisible. Their effect on film can be imagined in advance only with a certain accumulation of experience and knowledge. One such invisible requirement is depth of field.

Although it is often said that depth of field is visible in the finder of an SLR camera, it is not quite true, simply because our eye accepts as sharp a great part of those areas which are definitely unsharp in, say, an 8× enlargement. Therefore, we may not rely completely upon the manual aperture ring or A-M ring, since it gives only an approximate view of the depth of the sharp zone when we focus the lens to a medium or a farther distance. When we focus to a closer distance (within about five feet with a 50mm lens, and comparatively closer or farther in direct ratio to the changed focal length of the lens), we can see the limits of the sharp zone better because the details of the object are well magnified. Because of this limited capacity of the human eye, we have to act in the

same way in accurately determining the needed depth of field whether an SLR or an RF camera is used. Thus, we measure by focusing the closest and farthest points which have to fall within the sharp zone. Then we select an f/stop on the engraved depth-of-field scale of the lens barrel which coincides with both distances when we rotate the barrel.

Light Direction

Another effect not easy to evaluate, although it is quite visible, is the direction of light. It is not easy to evaluate because our visual perception responds to the contrast of light and shadow in a quite different way than film does. Since the contrast of tonal values changes when the direction of light has changed, we have to take this difference into consideration. Basically, film cannot surmount as great a range of contrast differences as the human eye can, and photographic paper is even more limited than film. Current films are able to render contrast differences of 1:1000, but paper narrows this ratio to about 1:30.

When the scene is frontlighted, we do not have too much trouble with exaggerated contrast. But when it is backlighted, we have to consider in advance which areas are to be reproduced in full detail, the shadow areas or the highlights. Usually, in backlighted situations, it is required that most of the shadow areas show up in detail. We have to determine the exposure accordingly. So we take a spot reading of the shadow areas with the SLR or a close reading with the RF, taking care that the light-sensitive eye of the meter does not receive direct illumination. This method works well with close-ups and semi-close-ups, but when a great area is incorporated into the picture, we have to take an average reading and double the exposure indicated by the meter. If, on the other hand, the shadow details of the objects are not important, we can rely upon the average reading. When the correct reproduction of both highlight and shadow values is required, we have to decrease contrast by filling in with light. This can be done by available reflecting surfaces (wall, book, newspaper, light-colored clothing, etc.) which are either incorporated into the picture area (for instance, a person reading a newspaper) or outside the frame of the picture (for instance, when the shadow areas of the subject are filled in with light reflected by a light colored wall close to the scene). In any case, a reflecting surface which is foreign to the content of the picture

should be outside the picture area. We can fill in with light by flash gun also, but I will speak of this technique later.

When we use fill-in light to avoid burned-in shadow details, the exposure reading of the shadow areas should be taken after the filling-in is in effect, of course.

Talking about reflections, we have to be aware of colored reflecting surfaces close to the photographed person, especially if this color is green (bushes, pictures taken in the forest or in the shadow of trees, green walls, etc.). Since panchromatic films are relatively less sensitive to this color than the human eye and the light meter, serious underexposure of the shadow areas occurs when we do not recognize this situation. This is doubly dangerous, because in consequence of the accommodation of the human viewing system, we cannot see this green reflection but accept the illumination as neutral. It is nevertheless recorded by the film in the form of missing detail. So when we take photographs in green-reflecting surroundings we have to increase the exposure by one full f/stop over the meter reading (assuming that all other pertinent considerations have been taken into account through the use of an exposure meter), if the subject has important shadow areas.

Before releasing the shutter we have to decide also how to transform colors into the gray scale. You learned in Chapter 1 the differences between the color perception of the human eye and the color rendition of film. You learned, also, how you can change the color rendition by using filters. Possessing this knowledge, you can evaluate the scene in terms of the needed rendition of colors.

After the decision is made as to what depth of field is needed and we select a particular f/stop for this, and after all the changes of the complex exposure value (filter factor, direction of light, special effects, etc., which influence this exposure value) are taken into account, we obtain a particular shutter speed. We have to determine whether this shutter speed fits the subject movement or not. If it does not, we have to change another factor of the exposure complex, such as decreasing depth of field by using a larger f/stop, using a lighter filter or no filter at all, or moving somewhat farther from the scene. The latter method offers a double advantage by increasing the depth of field and decreasing the visible speed of the subject due to the greater distance from the camera. What I described here may occur only in extreme cases since the speed of universal films yields more than sufficient depth of field and allows sufficient shutter speeds under average light conditions. So we have a great reserve for changing some factor of the exposure complex. But you should always keep in mind that a situation

in which you run out of this reserve may occur, especially when you use a slow film, or take photographs under dim light conditions.

On the other hand, this great reserve may work to our disadvantage. Sometimes we need a shallow depth of field for better separation of subject and background, or a longer exposure time to emphasize motion by blurred contours. In both cases, the universal films are too fast under average daylight conditions. Let's suppose that to obtain shallow depth of field we wish to use an aperture of $f/4$ when the available illumination is so strong that this aperture would require a 1/2000 sec. exposure time. It can be done with the old Canonflex R2000 and with the Canon F1, which feature this shutter speed, but what should the owners of all other cameras with a top shutter speed of 1/1000 or 1/500 do? (By the way, $f/4$ and 1/2000 sec. exposure is just normal for a 200–400 ASA film in average daylight conditions, so exceptionally strong illumination need not exist to exhaust one's reserve.)

Or let's take the other case when a slow shutter speed is needed. Once I took photographs that had to emphasize the flow of pedestrians at a busy street corner. To get enough blur I had to use a $\frac{1}{4}$ sec. exposure time in bright sunshine, with 200 ASA film; this required an aperture of around $f/90$. In the telephoto lens I was using, the smallest aperture was $f/32$; I had to change the universal film to a slow one (50 ASA) and I still had to use a yellow filter to cut excess light even at $f/32$. I could have solved the problem without changing the film by using a red filter, but unfortunately my 10X red filter was in my other gadget bag, so I had to change film.

Conclusion

1. Filters may be used to increase the required exposure, but beware of overfiltering the invisible blue radiation in the shadows. It may cause lack of details there, if you use a strong filter. To avoid this, decrease the filter factor one $f/$stop.

2. All the accessories of your camera should be with you when you are looking for pictures or on assignment.

Use of Flash or Speedlight

Although the 35mm system is designed to make use of any kind of light conditions, and is really able to do most jobs, situations may

arise when flash or speedlight has to be utilized. We can use these light sources in three ways:

1. As a main light source, when it is used straight.
2. As a man or supplementary source, when it is bounced.
3. As a fill-in light, either straight or bounced.

The most simple application of flash or strobe is when it is attached to the camera in such a way that its full light hits the subject. This simple technique is employed when our objective is only the simple recording of a situation or a person, and we do not care too much about photographic interpretation. It is all right when the situation alone makes the picture, as in the case of news photography. The f/stop can be calculated easily from the guide numbers appearing on each box of flash bulbs. Guide numbers are indicated in the instructions for use of speedlight units.

For speedlight set the dial to the red X mark. In this setting the shutter yields an overall exposure time of 1/60 sec. The exposure is made by the strong light of the electronic flash, the duration of which is 1/600 sec. and up, depending on the make of the unit. If the available light is dim enough, we have no trouble stopping fast movement. If the available light is strong enough to make an exposure on the film during the relatively long 1/60 sec. exposure time, a sharp contour of the moving subject is produced by the very short exposure time of the speedlight, and a blurred—although weak—contour is recorded by the existing light due to the long exposure time. To avoid this we can use a blue filter which cuts the strength of incandescent illumination (which is rich in yellow light rays), but does not affect the strength of the blue light of the electronic flash.

With FP type and AG-1 bulbs and flash cubes we can use any shutter speed except 1/30 sec.—some manufacturers mark FP bulbs as No. 6 or No. 6B (blue)—due to the relatively long and even burning time of the filling.

Class M bulbs also burn quite evenly, though their duration is shorter than that of the FP bulb, so they can be used from 1 sec. to 1/15 sec. exposure time.

MF type bulbs can be used only between 1 and 1/15 sec. so the stopping of action is done by the extremely short duration of the flash (about 1/250 sec.). Since the light of MF type bulbs is much stronger than that of the speedlight units in general use, we don't have to worry about double contours due to strong available light.

When the flash or strobe is used in such a way that the light coming from the flash head is bounced from a reflecting surface onto the subject, the illumination is more natural. This illumina-

tion is softer, also. Usually, we use the ceiling as a reflecting surface, if it is light colored. The effect is similar to the illumination which would originate from a chandelier. To calculate the f/stop to be used, the distance between camera-ceiling-subject has to be taken into account, and the aperture thus obtained must be doubled (use the next larger f/stop), because of the weakening effect of the reflecting surface, which is necessarily dull, even if it is clear white. If it is not white or cream, but gray or some other light color, open the diaphragm one more f/stop than would be necessary for a white ceiling. We can bounce the flash either by directing the flash head toward a point on the ceiling between the camera and subject, or— if we are close to the wall—toward the corner of the ceiling and the wall behind the camera. In the first case, the effect is toplighting and in the second case it is closer to frontlighting, although the toplight effect is maintained also.

Bounce light may serve as the main illumination, or as a supplementary illumination if the main illumination is not strong enough to permit a short exposure time or a smaller f/stop.

If the illumination is too contrasty, so that the shadow details of the subject would be burned in, we can use flash as a fill-in instead of a reflecting surface. Especially when photographing moving subjects, this kind of fill-in is very helpful. The exposure time and f/stop relationship is a constant value in the existing illumination. The addition of fill-in light changes the balance of this value and we must either vary the exposure, control the strength of the fill-in, or both. The fill-in light may be controlled by placing a diffuser over it or moving it farther from the subject. Whether the exposure or the strength of the fill-in is to be varied depends upon the tonal rendition desired.

In any case, the fill-in should be weak enough so that the aperture used is one f/stop smaller than would be necessary to achieve sufficient exposure from the fill-in alone. In this way, a natural appearance can be maintained.

Indoors, when the available illumination comes from one direction (window) and is quite strong, the shadow side of the subject can be lightened by bounced flash also. Where the flash head should be directed depends upon the direction of the main illumination. It is most practical to direct it toward the wall opposite the source of the main light. We have to calculate the strength of the fill-in

The light reflected from the newspaper serves as a natural fill-in light for the face of the person.

according to the rules described above, also maintaining the one f/stop less requirement I mentioned in the last paragraph.

As a fourth case for using flash I can mention the use of two or more flash heads simultaneously. As with flood lights, the flash heads may be positioned in several variations.

In general, two flash or strobe units are coupled by extension cords. Others, called "slave units," are actuated by a photocell.

Sunset.

Handicraft.

Play of Water.

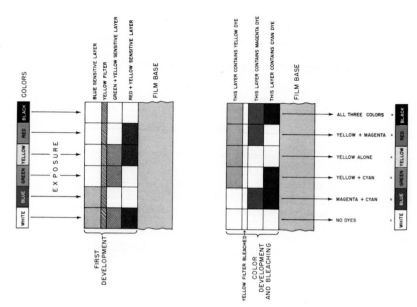

The course of development of colors in color reversal film.

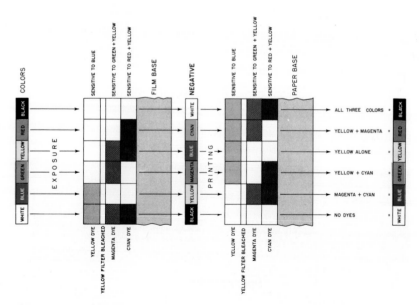

The course of development of colors of the negative–positive procedure.

7

Basic Rules of Composition

We have now reached the point at which we are familiar not only with the proper handling of the Canon and its various accessories and lenses, but also with the various effects of the tools, which should be taken into account when we are planning a photograph. Simple knowledge of these effects is not enough in planning a photograph that will command attention. Certain rules have to be observed as we reach for our objective. The application of these rules is called composition. Because they are very flexible, it is essential to know their bases in order to avoid misuse.

These rules are based primarily upon the inheritances of human beings and upon the psychological nature of human vision, together with its optical illusions, mistakes, accommodations, transformations, and dependence on side effects. The secondary bases of the rules of composition depend upon the fact that human vision is quite different from camera vision. It is not the object of this book to teach the psychological bases of photographic composition, but it is good to keep in your mind that they do exist. If you want to learn more about the psychology of composition you can find a thorough discussion in one of my previously published books, *Guide to Photographic Composition*. However, I will occasionally deal briefly with these bases when discussing the various rules.

At the outset, I will point out that humans are quite susceptible to geometric figures and are attracted by light areas. The combination of these basic features is used for the application of compositional means that determine the construction, but the applications and combinations of these means are innumerable.

Constructing the Composition

In order to clarify the ideas and simplify the approach I will divide them into two parts:

1. The bearers of the construction are:
 a) lines, b) figures, c) tonal qualities, d) patterns.
2. They are built into the construction by producing:
 a) depth effect, b) geometric effect, c) symmetric or asymmetric arrangement, d) contrast or similarity effect.

In addition to these effects, and often combined with them, the light effect has to be taken into account, since it is the most important basic element of photography. It may accentuate other compositional elements or it alone may produce these elements.

Lines

Lines in nature may be either open or hidden, curved or straight. In a photograph they can also appear open or hidden, and straight or curved, but their position within the frames of the photograph is decisive to the effect of the picture. So lines can be positioned within the frames in diagonal (or near diagonal), vertical, or horizontal directions. Moreover, if more than one line is present in a picture, these lines can converge, diverge, or run parallel. Since lines may appear in a photograph in various forms and in various positions, there are almost innumerable possibilities for showing line effect. Line effect can arouse various illusions in the mind of the spectator, and I shall try to analyze the effects in this relationship.

To give a favorable effect, lines should be set asymmetrically into the construction. For instance, it is definitely disadvantageous for the horizon line to divide the picture into two equal parts. The effect is more pleasant when it is positioned in the upper or lower area of the picture. Where in the upper or lower area? Perhaps into the so-called Golden Mean position, or between this position and the frame.

The division of an area according to the Golden Mean means an approximate 1/3:2/3 relationship. This ratio comes from the proportionate construction of the human body and other living creatures; it was recognized and used by artists for several thousand years. It is still the basic measurement for the beauty of proportions.

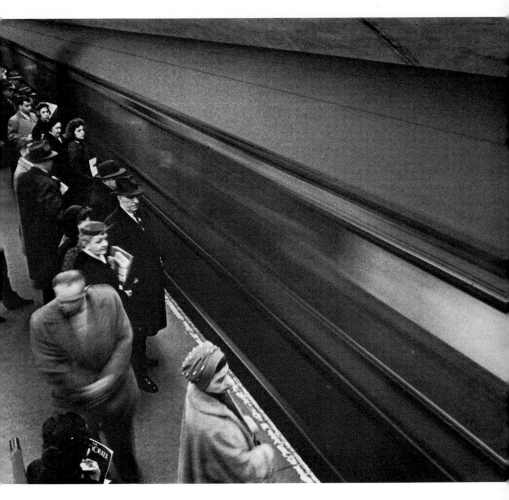

It is advantageous when compositional lines are positioned in a diagonal, or near diagonal direction.

This picture is a clear example of diagonal composition (above).

Convergent lines add great depth to this photo (opposite page).

When trees or poles are present in the picture we should definitely avoid placing them right in the center of the picture, but, rather, place them asymmetrically. In general, lines running parallel to the edge of the picture are disadvantageous and produce a dull or static effect. To gain a more dynamic effect, the diagonal setting of lines should be maintained. Conforming to the human habit of comprehension, it is preferable if the lines start in the left side of the picture. Convergent lines are very effective distance-producing elements of a photograph, and they should be directed into the depth in such a way that they meet each other in the Golden Mean position. But, since these compositional rules, as I stated before, are flexible, it is not mandatory to use the Golden Mean—an exaggerated asymmetry may often give more impact to a photograph. So it may be advantageous if we disregard the Golden Mean and set compositional lines approaching one of the corners. The basic function of compositional lines is to lead the eyes of the spectator to the content of the photograph, and/or emphasize the third dimension within the two-dimensional circumstances of photography.

Figures

By figures I mean those elements of a picture which are built into the construction to produce various effects—by their distribution in the picture area, their tonal qualities, and their shape. I do not mean necessarily the subjects of a photograph, although these or parts of them may take part in producing figure effect.

By their distribution they may appear in regular or irregular repetition. They may lie along some real or imaginary path, combined in this way with line effect. The diminution effect of figures of well-known sizes is often used for producing an illusion of depth. Because human nature is susceptible to geometric figures it is advantageous if figures are set into the nodes of an imaginary geometrical figure (for instance triangle-composition), or in geometric patterns.

Tonal qualities

The tonal qualities of figures may show contrast or similarity and are extremely useful for pointing out subject matter, or for laying stress upon a specific area of the picture. The effect plays an important role in maintaining the so-called balance of a photograph

118

Repetition of similarly shaped figures produces a depth effect.

or, if it is necessary, creating an out-of-balance appearance. Concerning the balance of the picture, it is desirable if dark tones are close to the edges and lighter figures are in the center of interest. It seems advantageous to maintain proper balance between figures of the same tonal qualities if their share in the picture area is equal. In the case of diminution effect, proportionate areas of different tonal qualities and sizes are able to produce balance also. A small white area can be balanced quite well by a large dark area. But the converse is not true due to the eye-catching nature of light tones. In consequence of the attraction of light tones, avoid placing a light spot close to the border of the picture whether it is connected with the content or with the construction of the photograph or not, because it may distract the attention of the spectator from the theme of the picture. In the case of lines, the phenomenon is reversed,

The distribution of tonal qualities determines the balance of a picture.

The eye-catching nature of light tones pinpoints the content of the
photograph.

since the eye, caught by the line at the edge of the picture, is led by it to the inside areas of the photograph where the subject is located.

Patterns

The pattern effect shows up a definite geometric construction, so it matches very well with human susceptibility. Geometric patterns may come into existence in photographic composition in the form of figure effect; namely, in the form of the so-called regular repetition of figures. Moreover, patterns can produce line effect also, and in this case it is combined with figure effect again in the form of the regular repetition of figures. Despite their definite geometric arrangement, patterns cannot always be called a geometric effect. The fine waves of the water surface cannot be called a geometric effect, but it is definitely a pattern effect. Stairways, showing a definite geometric formation, but sometimes producing a definite pattern effect, cannot be called a geometric effect.

Patterns are useful means to break the dull appearance of great coherent surfaces, and in this way they can contribute to the balance of the picture. Patterned surfaces, instead of plain, can efficiently counterbalance other areas of the picture construction. The best example of this is when branches on the upper part of the picture serve as a balance for the figures appearing in the foreground. A plain sky would not be able to maintain the balance of the composition.

If the pattern is used only for decoration or for balance, it is called an informal pattern. When the arrangement of compositional figures shows up a pattern-like distribution, it is called a geometric pattern.

Both geometric and informal patterns are extremely useful means for creating attraction.

Since we are now getting acquainted with the bearers of the construction, let us see how to use them for building the construction and what kind of effects may be achieved by this manner of this building.

Pattern effect in the background and strong line effect attract attention.

Regular pattern effect (opposite page).

Irregular pattern effect (above).

Depth composition

One of the problems in photography stems from the fact that the scene is seen as being three-dimensional in nature, but is reduced to two dimensions in the print. Though many scenes successfully lend themselves to a two-dimensional rendition, we may produce a more dynamic picture by creating the illusion of depth.

The bearers of the construction can be arranged in such a way that this arrangement can create an illusion of distance differences. Besides line and figure effects, light and haze effects can be used efficiently for producing the illusion of depth.

Let us examine these effects in respect to depth composition. These effects are often combined with each other, and may be hidden.

The 200mm lens compresses the distances within the picture area. In this way a favorable distribution of figures can be achieved within the frames of a photograph (opposite page).

Diminution creates an illusion of depth (below).

jects are distinct and well defined. Be careful of the effect of aerial haze when using longer focal length lenses, as I described in Chapter 5.

Regulated depth of field causes unsharpness of objects farther away and in this way emphasizes the distance differences. This effect, similar to the haze effect, is caused by the less recognizable details of objects thrown out of focus.

Geometric effect

As I stated previously, human beings are strongly affected by the use of geometric figures. Lines or figures built into the picture's construction in a regular arrangement following the outlines of a hidden geometric figure create an attractive effect. The means most often used for achieving geometric effect is the triangle composition, in which figures are placed at the vertices of an imaginary triangle. Compositional lines may produce the sides of a triangle, or both lines and figures may be combined in such a way that a triangle becomes recognizable when the picture is analyzed.

Symmetry and asymmetry

These aspects of construction are closely connected with geometric effect, since geometric figures are mostly symmetrical. Symmetry is usually unwanted in photographic composition, though this seems contradictory to the fact that geometric arrangements are eye-catching. But whether they are symmetrical or not, we notice these geometric arrangements in three dimensions in nature as well as in the photograph. This means these originally symmetrical arrangements lose their symmetry when they are projected by the lens to the two-dimensional plane of the film. If they did not lose their symmetry in perspective, we could not get an illusion of three dimensions in the two-dimensional circumstances of a photograph. So the lack of a symmetrical presentation corresponds to the human comprehension of strictly symmetric geometrical arrangements.

This comprehension is most agreeable when it follows the Golden Mean. But the feeling may be too agreeable and quiet, perhaps even dull, and may not arouse too much attention. Therefore, sometimes we can apply exaggerated asymmetry, or exaggerated symmetry in order to catch the attention of the spectator, who is inclined to recognize quickly the irregular, that which seems to be

An example of triangle composition.

working against the rules. By this psychological trick we can gain a stunning effect. But I have to emphasize that if you want to break the rules, first you have to be able to work *with* them.

Contrast and similarity effect

Although it is not rule-breaking to emphasize contrast in a photograph, it is definitely an effort to make use of the unusual. Two kinds of contrast effect exist: the mechanical, and the intellectual.

The mechanical contrast effect depends upon the contrast differences between tonal qualities of the photograph or comparison of sizes, or other features. The other effect takes into account the

Symmetric composition is sometimes effective.

Similar postures or behaviors strengthen the effect of a photograph.

contrast of postures, behaviors, expressions, and other such features of living creatures. The contrast effect strongly emphasizes the content of the photograph by appealing to the comparative sense of the spectator.

Our comparative sense does not work properly if we do not use the contrast effect properly. For example, a beautiful woman would not seem more beautiful if we were to photograph her in an ugly environment, although the contrast between the beauty and the ugliness may be immense. That beauty deserves a gorgeous environment.

Contrast effect may appeal to our rhythmic sense also, when contrasting ingredients of a picture are changed by repetition, such as tonal qualities and expressions.

The similarity effect appeals to our rhythmic sense also, though it is not the complete opposite of the contrast effect. And it too can work through technical and intellectual means. Similarly shaped figures can strengthen the effect of the main figures. Similar expressions of other faces can pinpoint the expression of the leading character of the picture.

Strictly speaking, only the technical means of contrast and similarity effect belong to the idea of how to build the bearers of the construction into the composition. It was, however, necessary to mention these intellectual means also, since the two are inseparable. Moreover, it is good to keep in mind that besides formal effects, a lot of psychological effects can be used in the art of photography.

Treating Background and Foreground

A tremendous advantage of the Canon SLR is that what we see in the mirror is exactly what will be projected onto the film, without depth parallax, and without that overall sharpness which is produced by the viewfinder of rangefinder cameras. In this way the image is more perceptible, and it is easier to judge and determine the background-foreground relationship.

Proper treatment of background and foreground and the relationship between these very important parts of a photograph may determine whether the photograph is liked or disliked by the viewers. It is possible that we do not have any foreground object in the picture but we always have some kind of background, even though it may not be tangible. So, when we shoot upwards, the empty (or cloudy) sky can be the background. On the other hand, the ground

The ground can serve as a favorable plain background.

can serve as a background also when the shooting angle is directed downwards from a high camera position.

Background may belong to the composition or it may support or emphasize the picture content. If it does not, it is advantageous that it should as inconspicuous as possible; a topsy-turvy distribution of tonal qualities in the background should definitely be avoided. By regulated depth of field we can overcome the tendency of the subject to blend into the background. A patterned background can replace a smooth one, and it may be very decorative. If we cannot avoid very noticeable lines or figures in the background, we should take care that these lines or figures do not coincide with the main figures of the photograph. (For instance, it is not desirable that a pole should seem to grow out of the head or the shoulder of the person photographed.)

134

Background may belong to the composition or it may emphasize or support the picture content.

Background objects or subjects can support the picture content by intellectual means also (above).

By regulating depth of field we can prevent the subject from blending into the background (opposite page).

Although by the regulation of depth of field the background was thrown out of focus, the strong lines of the two trees on the right side, in coincidence with the picture content, is rather disadvantageous (above).

The picture is printed upside down, so the foreground (the mirroring in the water) becomes the picture content (below).

The share of the background in the picture area can be regulated not only by the shooting angle but by the selection of the proper focal-length lens. Properly speaking, when using a longer focal-length lens, we select a segment of the available background, thus eliminating the disturbing parts of it and/or of the surroundings. And by the same token, we may throw out of focus remaining disturbing elements of the background, pointing out in this way the content of the photograph.

On the other hand, shorter focal-length lenses may catch a large area of both the background and the foreground. If we show a large area of the foreground, we should take care that it isn't empty. Hence, we generally use a wide-angle lens when we wish to incorporate some close-lying object in the picture area, which otherwise (maintaining the compositional rules) would be left out. Thus, we can emphasize foreground objects, or we can use them as decoration, as a natural frame, or as elements producing depth effect. The foreground, whether used for decoration or for the sake of depth composition, or both, has to be treated in connection with the main area of the picture. If it is not, the foreground becomes the main area of the photograph.

As we understood from the foregoing, the picture area is generally divided into three parts: the foreground, which contains decorative, depth-producing, or framing elements, or all three; the middleground, where the picture content is located; and the background. The relationship between these three parts of the picture is subjected to innumerable variations. Therefore, no rigid rules can be set in connection with it, and only the situation, the photographer's taste and imagination, and the requirement of each picture determine the relationship between them. My job is not to show what to determine, but to explain how to fulfill your determination through the means offered by the Canon system of photography.

In Chapter 5, when I was dealing with the use of interchangeable lenses, I discussed the effects of various focal-length lenses in connection with perspective and with the apparent size of objects distributed within the picture area. These effects also determined the apparent distances between these objects as well as apparent distances between foreground, middleground, and background, respective to the blending of these parts of the picture area. For the sake of pinpointing the topic, I repeat here briefly what was said:

1. By changing the focal length of the lens together with changing the camera position, we can regulate the foreground, middleground, and background relationship in the effect of apparent distances and apparent sizes of objects incorporated into these areas.

In many cases the picture is divided into the foreground, middle-ground, and background.

By selecting the proper focal length lens, we can cut off disturbing surroundings, and we can throw the disturbing background out of focus.

2. By changing the focal length of the lens without changing the camera position, we can regulate the sharing of foreground and background areas within the picture area. That means that when the focal length increases, close objects gradually disappear from the picture area and more distant objects become recognized as foreground objects. Gradually, smaller segments of the background area become incorporated into the picture area. In an extreme case foreground and background blend into each other and the visual distance becomes compressed. When the focal length of the lens decreases, the effect is reversed, and in an extreme case, the close foreground dominates the picture area.

The sharing of the picture area in respect to foreground and background can be regulated by the shooting angle of the camera also. In general, a low camera position emphasizes foreground objects, making them appear higher. A high camera position may diminish the significance of the natural background by placing the horizon line lower. The high camera position, when the camera overlooks the scene, is very favorable for depth composition, since the progress of compositional lines is more obvious and the position of figures lying each behind the other shows a more favorable separation.

8

Color Photography

Basic Technical Aspects

When we load our Canon with a roll of color film, we have to know under what conditions the film will be used, just as we do in black-and-white photography. But this similarity is only superficial. In black-and-white photography, if we use a high-speed film under daylight conditions, nothing more would occur than an increase in graininess, and, occasionally, a decrease in our ability to use the means of regulated depth of field, because of the small lens apertures which must be used with fast films. And, conversely, if we used a slow film under artificial light conditions, we should have to use a large f/stop, which perhaps might not permit the necessary depth of field, or we should have to use a shutter speed slower than the one required for an unblurred rendition of movement. In this case, then, we are also limited at times. But it cannot be said that any black-and-white film cannot be used at all under conditions different from those for which it was designed. The pictures taken with the unsuitable film might still be good.

In color photography the situation is quite different. This difference is caused by the fact that human beings accommodate themselves to illumination, and comprehend the yellow-red illumination of incandescent light as white, just as they comprehend the bluish cast of the shadows under a cloudless blue sky as colorless. Color film, however, does not feature a built-in accommodation ability. Therefore, with films of different sensitization, the color rendition should match the color comprehension of the human sense in changed conditions. The color sensitivity of tungsten-type color film is shifted toward blue in comparison with the color sensitivity of daylight-type color film. Therefore, if we would use tungsten film under daylight conditions, a strong bluish cast will be produced

in the picture, and, conversely, if we use daylight film under in-candescent light, the pictures will turn out much more reddish-yellow than the scene comprehended in reality.

Moreover, the color of the illumination for which the film was designed and is used changes within certain limits, but the film records these changes also.

These are the basic aspects that even a beginner should know when he or she takes color photographs—and the fact that color distortions caused by changes in illumination can be corrected by filters. But putting the proper filter on the lens is not a cure-all for color distortion, because besides this basic and well known as-pect, other facts have to be taken into account. These facts belong within the bounds of color theory and color psychology.

Color Theory and Color Psychology

The colorless illumination of the sun, and of any other light source which is accepted and comprehended as colorless, is actually a mixture of colored light rays. We can decompose this colorless light by using a prism.

Since the colorless illumination contains all the colors of nature, the objects which reflect this colorless illumination proportionately seem to be colorless also. The greater the percentage of illumination reflected proportionately, the lighter is the object. If it does not reflect a recognizable amount of light, it appears black. If the object does not reflect the received light proportionately, but only one part of the entire spectrum is reflected, the object appears in the color that is reflected. If the objects reflect two or more parts of colored light rays, the color of the object is the mixture of the reflected light rays. It is not necessary to mix all colors to obtain white. Ac-tually, this mixture can be colorless again if only three certain colors of the entire spectrum are reflected by the object. These colors are blue, green, and red, and are called fundamental colors. If we put these fundamental colors into the nodes of a triangle, and we mix the two colors next to each other, we obtain a new color. If we mix this new color with the opposite color in the triangle, we get white again. The color that has to be mixed with a certain other color to get white is called a complementary color. If you look at the color circle (page 157), you will realize that we have really two color triangles, and you can see that the colors directly opposite one another on the circle are complementary. Mixing col-

144

ored light rays is called the *additive mixing of colors* and the exposure of the three layers of color film is based on this system.

In development, dyes are produced in each layer of color film and the dye in each case is the color approximately complementary to the sensitivity of that layer. So, in the blue-sensitive layer yellow dye is developed; in the green-sensitive, magenta; and in the red-sensitive layer, cyan. These colors, when viewed or projected, produce color mixtures according to the *subtractive mixing* system. So when we mix the three fundamental colors by superimposing the light rays of three different light sources (additive procedure) we obtain white light, but when we use only one light source, whose light is gradually changed by the three fundamental colors (subtractive procedure) we get black.

From the foregoing you can realize that strict ties exist when we mix colors, and you may imagine that this has something to do with the psychological nature of our color perception, and that the missing color of the color triangle produces white when we add it to the mixture of the two other colors. As you know, the mixture of these two other colors and the missing color are complementary to each other. Because of an optical illusion, we are likely to see that missing color in a white area adjacent to an area which is complementary to the missing color. In other words, we are likely to imagine in a white area a color which is complementary to the adjacent colored area.

Obviously, if we can imagine color that is not there, our color comprehension is increased if that color does exist in reality. This means that when complementary colors are next to each other, their effect is strengthened. This is a very important fact in color photography, and has to be taken into account not only when photographs are taken, but in several other phases of color photography. For instance, when you project a transparency with a bluish cast after one with a yellow cast, the apparent bluishness of the second transparency is increased, so the effect on the viewer may be unfavorable.

Just as the complementary colors increase the *contrast effect*, the adjacent colors have a *harmonizing effect*. Both kinds of application of colors in the construction of a color photograph can raise the attractiveness of the picture. If you are studying the color circle you can find the favorable color combinations either for contrast effect or for harmonizing effect.

These effects of harmonizing and contrasting colors are involved also in color psychology.

This matter is related to the fact that our brain does not always believe what our eyes report to it, and it transforms this report according to its needs. I mentioned the existence of shadows which we see as neutral but are recorded by the film as blue.

Due to reflections, other kinds of discoloration of shadow also may come into existence. If the reflecting surfaces are incorporated into the frames of the photograph, we comprehend this discoloration as quite natural. But when the reflecting surfaces are outside the picture area, a strange effect occurs when the transparency is projected or the print is viewed. When, in nature, we saw the subject together with its surroundings, and so together with the reflecting surface, the reflection did not seem too evident. But it became conspicuous when we saw the object without the reflecting surface in the black frame of the projected image. The most obvious example of this kind of reflection is green-reflecting surroundings.

On the other hand, reflected colors and projected colored light can be used consciously for special effects and there are no restrictions to hinder the photographer's imagination when composing a picture. However, he or she must know in advance the factors which have to be taken into consideration.

To overcome blue or green reflections we can use a gold reflecting surface instead of the regular silver one to fill in the shadow areas of the subject, or we can use blue flash bulbs if we consider the proper strength of the effect.

Failure to recognize discolored shadows is the result of the transforming action of our brain, which interprets the objects around us in a comparative manner according to an inherited illusion. But we recognize the slightest discoloration when we look at the transparency or the color print, because we can compare their color rendition with the existing colors of our environment.

The effects I described in the two previous sections have to be taken into account when we try to evaluate the effect of our color photographs. We have to compose the picture in such a way that these effects are combined with other effects and means of photographic composition and with some additional special means of color composition.

Special Means of Color Composition

Besides the regular compositional means of black-and-white photography (line, figure, depth, repetition, contrast effects, etc.), we also have to take into account the special effects of different

colors and we have to combine these special effects with black-and-white means, unless we abandon these means for the sake of a special performance or for pure abstraction.

First of all, I have to emphasize that the topsy-turvy distribution of colors in a color photograph is just as unattractive as the topsy-turvy distribution of tonal qualities in a black-and-white photograph. Moreover, it is rather advantageous if we use large colored areas instead of small spots, except when a special effect is desired. The effect of distribution of colors can be easily judged on the ground glass of the Canon SLR, which presents a "living" transparency. However, the effect of this "living" transparency does not in every respect match the real transparency or the color print as viewed by other persons, because we are dependent upon our subjective impressions, which cannot influence the opinion of the viewer. Therefore, we have to understand the effect of colors.

As a basic approach to an understanding of color we distinguish between warm and cold colors. The warm colors are red, orange, yellow, and their transitions. Warm colors attract the eye much more than cold colors, if the saturation of the two colors and/or the comparative dark-light values are fairly equal.

The effects of the light-dark relationship in black-and-white photography can be applied in color photography too, but in addition to this we can use the warm-cold color combination and the contrasting effect of the complementary color to the same effect. Moreover, warm colors are called approaching colors, while cold colors are departing colors. This approaching-departing effect of warm and cold colors can be used as an effective means for depth composition. The warm and bright color spot surrounded by a cold color plays the same role in color photography as the eye-catching effect of a highlight in dark surroundings in black-and-white photography.

So, many effects of black-and-white photography can be translated into the circumstances of color photography, if we learn to understand colors. If we do this, our job of producing well composed color photographs is easier than it is in black and white, since color is our natural comprehension, and the gray scale involves the transformation of colors. So, in color photography we do not have to concern ourselves with such means of separation as filters, regulated depth of field, light effects, etc. To avoid, for instance, the subject blending into the background, we can depend on the different colors of the subject and background.

In color photography as well as in black and white, we should try to keep the construction as simple as possible. That is why those

color photographs which contain only a few adjacent colors on great coherent areas, and only a few small spots of a brighter color of the same family, or of the contrasting family, are so tasteful and attractive. Another variation of a simple construction is when neutral (white, gray, black) areas are present in great majority and only a few color spots indicate that it is a color picture. Backlighting can produce such a "colorless" effect, though the dark areas may be brown, blue or green instead of gray. But the colors of the highlight areas are sparkling especially when translucent objects are present, such as clothing, leaves, colored glass, balloons, etc. In backlighting, the exposure has to be determined for the favorable rendition of the well illuminated areas, and if we need the proper rendition of the shadow areas also, we have to fill in with light.

Mixed Light

As I explained at the beginning of this chapter, each type of illumination requires an appropriate type of film (color-negative film is an exception if the illumination is homogeneous), although by using color conversion filters we can use tungsten-type films under daylight conditions and vice-versa. With the appropriate type of film we get the proper results in any kind of illumination. But what happens when more than one type of illumination is present within the picture area? Say, when the main illumination of a room is provided by floodlight, but daylight also comes in through the window. The film is unable to render properly both kinds of light whether reversal or negative film is used. If tungsten film were used in that situation, the areas illuminated by the daylight would appear quite blue, and if daylight film were used, a yellowish-red cast would appear in those areas of the room which were illuminated by the floodlight. Therefore, we have to be careful of the homogeneity of the illumination unless we intend to achieve some kind of special effect through twofold illumination.

Each type of film is sensitized in such a way that its color rendition is correct if the object receives the illumination within certain limits of Kelvin grades. The Kelvin grades indicate the so-called color temperature of the illumination. The color temperature is expressed by centigrade degrees taken from the point of absolute zero (minus 273 degrees) which is necessary to obtain the color of a glowing "absolute black" object. The lower the Kelvin grade, the more reddish is the glow; the higher the temperature of the glowing "absolute black" object, the more bluish is its color. The

red-blue content of any kind of illumination can be measured by certain instruments (color-temperature meters), and can be compared with the Kelvin grades.

The following table indicates the color temperature of various light sources and illuminations in approximate Kelvin grades:

Average daylight illumination	5000-6000
Blue sky	12000-16000
Overcast sky	6000-8000
Daylight for 2 hours after sunrise and 2 hours before sunset	4000-5000
Room illumination	depends upon what kind of illumination is reflected into the room, combined with the effect of the sky.
Speedlight (varies with make)	5000-6500
Blue flash bulbs	5000-6000
Clear flash bulbs	3400-3800
Photoflood lamps	3200-3400
100 watt incandescent lamps	2700-2800

Moreover, it is good to know that the same sort of daylight illumination contains more blue light rays in April and May than in any other part of the year, and the blue content is the lowest from November till March in the northern hemisphere.

It is easy to imagine that the sensitization of the different types of films is executed in such a way that it should render properly colors within Kelvin grades corresponding to its sensitization.

So daylight-type film is sensitized to render colors properly within 5500–6000 K. For use with tungsten light there is Type A film, sensitized to 3200 K and Type B for 3400 K.

9

Useful Data and Tables

As a practicing photographer I have attempted to present in this collection of data and tables only those of real use. I deliberately omitted such data as the depth of field of different focal length lenses, since these figures are engraved on the lens barrel. I do not recommend developing times for various film-developer combinations, since these are available in the instructions which come with the various developers. Besides, these developing times are flexible, and depend upon personal tastes and needs.

1. Inch-Centimeter Conversion Table

Inches	Centimeters	Centimeters	Inches	
1	2.54	1	0.394	(3/8)
2	5.08	2	0.787	(3/4)
3	7.62	3	1.181	(1-3/16)
4	10.16	4	1.575	(1-9/16)
5	12.70	5	1.969	(1-15/16)
6	15.44	6	2.362	(2-5/16)
7	17.78	7	2.756	(2-3/4)
8	20.32	8	3.150	(3-1/8)
9	22.86	9	3.543	(3-1/2)

2. Weight Conversion Table

Grams	Ounces/Grains		Ounces	Grains	Grams
1	15½	grains	¼	110	7
2	31	grains	½	219	14½
3	46½	grains	¾	329	22
4	62	grains	1	437½	29
5	77½	grains			
6	93	grains			
7	108½	grains			
8	124	grains			
9	139½	grains			
10	155	grains			
25	¾ oz. and 62 grains				
50	1¾ oz.				
100	3½ oz.				

3. Liquid Measures

Quarts	Ounces	Milliliters
2	64	1900
1	32	950
½	16	475
¼	8	238
	4	120
	2	60
	1	30

4. ASA—DIN Conversion Table

ASA	/10 DIN		ASA	/10 DIN		ASA	/10 DIN
8	10		64	19		250	25
10	11		80	20		320	26
12	12		100	21		400	27
16	13		125	22		500	28
20	14		160	23		640	29
25	15		200	24		800	30
32	16					1000	31
40	17					1300	32
50	18					1600	33
						2000	34
						2600	35
						3200	36
						4000	37

Doubled ASA Exp. Index is equivalent to 3 mark higher DIN index and with doubled sensitivity of the film.

Slow Films

Properties: Highest resolution, no noticeable grain. Some films may build up too strong contrast if development is improper.
Recommended Developers: FR X-22, Promicrol, Rodinal, D-76, Microdol-X, Atomal, Microphen, Perinal, and FR X-100.

Film	ASA Daylight	ASA Tungsten
Agfa Isopan FF	25	20
Adox KB 14	40	32
Adox KB 17	80	64
Kodak Panatomic-X	32	32
Ilford Pan F	80	64

Medium-Speed Films

Properties: Excellent resolution and grain structure, except if severely overexposed. With proper development, films require a No. 3 contrast paper or the equivalent filter with variable contrast paper.
Recommended Developers: Atomal, Microdol-X, Promicrol, Microphen, FR X-44, Neofin Red, Ethol UFG, D-76, and FR X-100.

Film	ASA Daylight	ASA Tungsten
Adox KB 21	200	160
Ilford FP-4	200	160
Kodak Plus-X	125	125

Fast Films

Properties: Resolution and graininess are acceptable at normal developing times. Despite common belief, these films may build up higher contrast by improper development. However, the general characteristic of most of these films is on the soft side.
Recommended Developers: FR X-44, FR X-100, Atomal, Promicrol, Ethol UFG, Microphen, D-23, D-76, and Acufine.

Film	ASA Daylight	ASA Tungsten
Agfa Isopan Record	1300	1000
GAF Super Hypan	500	400
Ilford HP-4	650	500
Kodak Tri-X	400	400
Kodak 2475 Recording	1000	1000

6. Distinguishing Features of the Canon Filters

Type of Filters	Ultra-violet	Violet	Blue	Bluish green	Green	Yellow	Orange	Red	Infra Red	JIS Classification
Wave Length (mμ)	300 400	440	480	520	560	600	650	700	800	
UV										SL 39.3C
Y1										SY 44.2C
Y3										SY 50.2C
G1										MG 55. C
O1										SO 56.2C
R1										SR 60.2C
Sky-light										

7. Angle of View and Magnification of Different Focal-Length Lenses

Lens	Angle of view (degrees)	Magnification
17mm	104	0.34
19mm	96	0.38
25mm	82	0.5
28mm	75	0.56
35mm	64	0.7
50mm	46	1.0
85mm	29	1.7
100mm	24	2.0
135mm	18	2.7
200mm	12	4.0
300mm	8	6.0
400mm	6	8.0
600mm	4	12.0
800mm	3	16.0
1000mm	2.4	20.0

8. Canon Filters

Types of Canon Filters	Filter Factor	Filter Uses and Effects
UV (Ultra Violet) (SL39.3C)	1x	Recommended especially for high mountain areas where ultraviolet rays are strong. Absorbs ultraviolet rays only and has no effect on other colors. When using super-sensitive high speed panchromatic films which require the screening of the undesired ultraviolet rays. Also recommended for use with color film.
Y1 (Light Yellow) (SY44.2C)	1.5x	For landscapes and portraits with low sun, gives correction of tonal values darkening the navy blue of the sea and brings out the whiteness of the clouds by darkening the sky. Red and yellow objects are rendered lighter. This filter absorbs colors ranging from ultraviolet to certain blues.
Y3 (Yellow) (SY50.2C)	2x	For landscapes and still life. This filter is similar to Y1 but the effects are stronger. One of its characteristics is to bring out a contrast between the foreground and the background.
G1 (Light Green) (MG55.C)	3x	For portraits against the sky, natural reproduction of foliage, gives correction of tonal values. This filter allows the green colors to pass freely while screening the other colors which are stronger in the order from yellow to blue and from orange to red. This filter most nearly approximates the actual depths of the various colors as actually seen with our eyes.
O1 (Orange) (SO56.2C)	3x	For haze penetration, contrast in marine scenes, distant landscapes, aerial photography and sky-cloud contrast. Colors from ultraviolet to certain greens are absorbed by this filter, blue becomes fairly dark, and yellow and red appear lighter than interpreted with our eyes.
R1 (Red) (SR60.2C)	6x	For distant landscapes, exaggerated sky-cloud contrast with a very dark sky, gives dramatic and interesting effects. Gives greater contrast than yellow or orange filters. This filter can be used with either the infrared or panchromatic film.

9. Depth of Field (mm) for Close-ups with Canon 50mm Lens

Reduction Ratio	Field	Film Plane to Object Distance	f:1.8		f:2.8		f:3.5		f:4		f:5.6		f:8		f:11		f:16	
1 : 17	408 × 612	984	+	19.7	+	31.0	+	39.0	+	44.9	+	64.1	+	94.4	+	135.0	+	210.9
			−	18.9	−	29.1	−	36.0	−	41.0	−	56.3	−	78.5	−	104.6	−	144.7
1 : 15	360 × 540	880	+	15.4	+	24.2	+	30.5	+	35.0	+	49.9	+	73.1	+	104.1	+	160.9
			−	14.9	−	22.9	−	28.4	−	32.3	−	44.5	−	62.1	−	83.1	−	115.6
1 : 12	288 × 432	727	+	10.0	+	15.7	+	19.7	+	22.6	+	32.0	+	46.7	+	66.0	+	100.5
			−	9.7	−	14.9	−	18.5	−	21.1	−	29.2	−	41.0	−	55.1	−	77.3
1 : 10	240 × 360	625	+	7.0	+	11.0	+	13.8	+	15.9	+	22.4	+	32.6	+	45.8	+	68.6
			−	6.9	−	10.6	−	13.2	−	15.0	−	20.8	−	29.2	−	39.4	−	55.6
1 : 7.5	180 × 270	497	+	4.1	+	6.3	+	8.0	+	9.1	+	12.9	+	18.6	+	26.0	+	38.9
			−	4.0	−	6.2	−	7.7	−	8.8	−	12.2	−	17.2	−	23.2	−	33.0
1 : 5	120 × 180	371	+	1.9	+	3.0	+	3.7	+	4.3	+	6.0	+	8.6	+	12.0	+	17.8
			−	1.9	−	2.9	−	3.6	−	4.1	−	5.8	−	8.2	−	11.1	−	16.0
1 : 4	96 × 144	322	+	1.3	+	2.0	+	2.5	+	2.8	+	4.0	+	5.7	+	7.9	+	11.4
			−	1.3	−	1.9	−	2.4	−	2.9	−	3.9	−	5.5	−	7.5	−	10.8
1 : 3	72 × 108	275	+	0.8	+	1.2	+	1.5	+	1.7	+	2.4	+	3.5	+	4.7	+	7.0
			−	0.8	−	1.2	−	1.4	−	1.6	−	2.3	−	3.3	−	4.6	−	6.5
1 : 2.5	60 × 90	242	+	0.6	+	0.9	+	1.1	+	1.2	+	1.7	+	2.5	+	3.4	+	5.0
			−	0.6	−	0.9	−	1.1	−	1.2	−	1.7	−	2.4	−	3.3	−	4.7
1 : 2	48 × 72	232	+	0.4	+	0.6	+	0.7	+	0.8	+	1.2	+	1.7	+	2.3	+	3.4
			−	0.4	−	0.6	−	0.7	−	0.8	−	1.2	−	1.6	−	2.2	−	3.2
1 : 1.5	36 × 54	215	+	0.2	+	0.4	+	0.5	+	0.6	+	0.8	+	1.1	+	1.5	+	2.2
			−	0.2	−	0.4	−	0.5	−	0.6	−	0.8	−	1.0	−	1.4	−	2.1
1 : 1	24 × 36	206	+	0.1	+	0.2	+	0.2	+	0.3	+	0.4	+	0.6	+	0.8	+	1.1
			−	0.1	−	0.2	−	0.2	−	0.3	−	0.4	−	0.6	−	0.8	−	1.1

10. Shutter Speeds Needed to Stop Various Movements

Calculated on a base of 30 feet shooting distance. Double the speeds given if the shooting distance is 15 feet. Halve the speeds given if the shooting distance is 60 feet.

	Axial	Diagonal	Perpendicular
Slow moving cars, quiet pedestrians, street scenes, parades, slow boats	30	60	125
Playing children, hurrying people, cyclists, equestrians, waves, waterfalls, swimmers	60	125	250
Racers, jumping, skating, horse racing, quick moving cars	125	250	500
Tennis, baseball, basketball, football, water skiing, motorboating, birds in flight, fast rides in the amusement park, trains	250	500	1000
All sports and racing when they are at their peak of speed	500	1000	2000

Colors opposite each other on the color circle are complementary. Colors in the nodes of the triangles produce white light when mixed, as do complementary colors.

Index